The Surrealists: Revolutionaries in art & writing 1919–35

THE SURI

JEMIMA MONTAGU
REALISTS
REVOLUTIONARIES IN ART & WRITING 1919–35

Tate Publishing

The Surrealists
Revolutionaries in art & writing 1919–35

First published in 2002 by order of the Tate Trustees by:
Tate Publishing
a division of Tate Enterprises Ltd
Millbank, London SW1P 4RG

British Library Cataloguing-in-Publication Data

A catalogue record for this book is available from the British Library

ISBN 1 85437 367 6

Design: Peter Brawne | Matter
Printer: Graphicom, Italy

Front cover:
René Magritte **The Betrayal of Images** (detail) 1929
Oil on canvas, 64.5 x 94
Los Angeles County Museum of Art. Purchased with funds provided by the Mr and Mrs William Preston Harrison Collection / Bridgeman Art Library
© ADAGP, Paris and DACS, London 2002
(see page 86)

Back cover :
Salvador Dalí **Lobster Telephone** 1936
Plastic, painted plaster and mixed media, 17.8 x 33 x 17.8
Tate, London
© Salvador Dalí, Gala-Salvador-Dalí Foundation / DACS, London 2002
(see page 99)

Editorial note:
Dimensions of works are in centimetres, height before width

Acknowledgements:

This book is dedicated to Nick Laessing.

I would like to thank my parents, Matthew Gale, the late David Gascoyne, Catherine Kinley, Patrice Blouin, Arnaud Macé, Anthea Snow, John Jervis and Liz Alsop, who initiated this book.

Contents

The movement of artists and writers known as Surrealism was officially launched with the grand idealism of André Breton's first *Manifesto of Surrealism*, published in 1924. The manifesto called upon 'man, that inveterate dreamer' to defy the rational, logical world and to allow the imagination to 'reclaim its rights'. 'I believe', wrote Breton, 'in the future resolution of these two states, dream and reality, which are seemingly so contradictory, into a kind of absolute reality, a *surreality*.'

Breton, like all the founder members, was a writer and poet, and Surrealism began as a literary movement bent on revitalising life through language. It quickly became clear that Surrealist ideas were also of interest to artists, and despite some misgivings, the movement was repositioned as a revolution in both art and writing.

Although Surrealism is primarily known today for the artists and images associated with the movement – Salvador Dalí's melting clocks or René Magritte's bowler hats – it was in fact an interdisciplinary movement in which artists and writers played an equally important role. This book draws on the combined visual and verbal history of Surrealism in bringing together major art works and texts by the key figures of the group. Each chapter focuses upon an artist and a writer (except for the chapter on Dalí), examining a selection of their works in relation to a prominent Surrealist theme. Some of these pairings attest to specific friendships or collaborations, while others demonstrate the cross-currents of ideas within the Surrealist *milieu*. The book confines itself to what is known as the 'heroic period' of the movement's history. It begins with the origin of the movement in the early 1920s, covers the first and second manifestoes, and ends in 1935, when the group was expelled from the French Communist Party. Although the movement continued well into the 1960s, after this point it became increasingly fragmented and diverse. Many of the original members

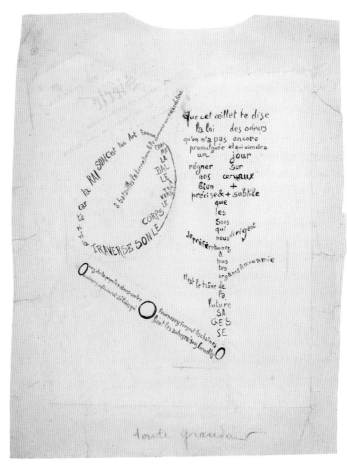

had left and the character of the movement changed. This time-frame encompasses the fertile period of Surrealism's origin and development, the foundation of the movement's key principles, and the period of closest collaboration and unity.

One of the important metaphors associated with Surrealism centres upon the idea of 'communicating vessels', an image that suggests the interpenetration of the rational and irrational world, the waking state and dream. It could also describe the relationships between the artists and writers themselves, whose friendships, collaborations and constant ferment of shared ideas bore the fruit of the Surrealist movement.

Origins

Surrealism was born in the climate of revolt after the horrors of the First World War

(1914–18). 'We young people came back from the war dazed', wrote the artist Max Ernst, 'and our disgust simply had to find an outlet. This quite naturally took the form of attacks on the foundations of the civilisations that had brought the war about – attacks on language, syntax, logic, literature, painting and so forth.' While many artists and writers sought the artistic safety-nets of traditional forms and styles, creating a post-war revival of Classicism that became known as the '*rappel à l'ordre*', or 'call to order', there was a younger generation who knew that a radical reappraisal of received ideas was the only way forward.

It has been observed that Surrealism evolved and dissolved in the space between two battle-cries. The first was the declaration made by Karl Marx that it is everyone's responsibility to 'transform the

world', and the second was the poet Arthur Rimbaud's famous imperative: 'change life'. Although apparently similar in aim, there is nevertheless a gulf of difference between the two. Marx's statement is made in the context of a political and social revolution, in which a transformed world could be achieved only through collective political struggle. Rimbaud's statement was a quasi-religious invocation to absolute and total artistic freedom, expressing faith in the power of art to revitalise the world. For Rimbaud it is through poetry, not politics, that life can be changed. Although Marx and Rimbaud both became established figures in the Surrealist pantheon, the Surrealists were to spend most of the late 1920s trying to reconcile these differences: artistic freedom, on the one hand, and political struggle on the other.

The first Surrealist manifesto deliberately proclaims a radical literary heritage. In opposition to the Realist tradition in nineteenth-century French literature, the Surrealists invoked Romantic and Symbolist poets:

Baudelaire is Surrealist in morality.
Rimbaud is Surrealist in the way he lived, and elsewhere.
Mallarmé is Surrealist when he is confiding.
Jarry is Surrealist in absinthe.
Saint-Pol-Roux is Surrealist in his use of symbols.

These writers exemplified a new spirit of poetry which had other-worldly or cosmic ambitions, faith in the supra-rational, occult and esoteric, and a new lyrical grandeur. The writing of Arthur Rimbaud (1854–1891) engaged with the idea of what life and art could be, as he expressed in a letter of 1871: 'I say that you have to be a seer, you have to make yourself a seer. The poet makes himself a seer by a long vast rational *disordering of all the senses.*' A contemporary of Rimbaud who also caught the Surrealist imagination was Isidore Ducasse, the self-styled Comte de Lautréamont (1846–1870), who wrote two

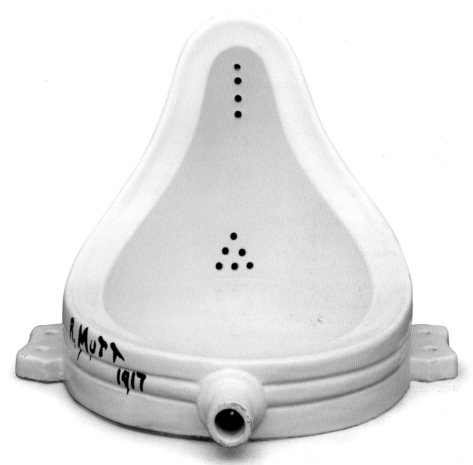

extraordinary works, *Les Chants de Maldoror* (*Cantos of Maldoror*) (1868) and *Poésies* (*Poetry*) (1870). Breton was profoundly affected by the hallucinatory, stream-of-consciousness prose in the *Chants*, describing them as 'the expression of a total revelation that seems to exceed human possibility'. He resurrected Lautréamont's reputation by transcribing the only surviving copy of *Poésies* by hand in the Bibliothèque Nationale in Paris so that a new edition of the work could be published. Another key figure, from a slightly earlier period, was the Marquis de Sade (1740–1814). De Sade's erotic and political writings prompted the Surrealist poet Paul Eluard to praise him 'for having desired to restore to civilised man the force of his primitive instincts ... [and] set free the imagination of love and for having fought desperately for absolute justice and equality'.

Of the generation directly preceding the Surrealists, the poet and writer Guillaume Apollinaire (1880–1918) stands out as the pivotal figure of the pre-war avant-garde. He was a champion of Cubism, and likewise his poetry demonstrated a radical disrespect for traditional poetic syntax and grammar. His ground-breaking volume *Alcools* (1913) incorporated snatches of overheard conversation producing a kind of fragmented impressionism, while *Calligrammes* (1918) introduced a new form of poetry in which the shape of the text imitated the subject of the poem. It was Apollinaire who coined the term 'Surrealism', when he subtitled his play *Les Mamelles de Tirésias* (*The Breasts of Tiresias*) (1917) 'A Surrealist Drama'. For the Surrealists Apollinaire was the guiding light, a cultural pioneer whose work crossed many artistic boundaries and

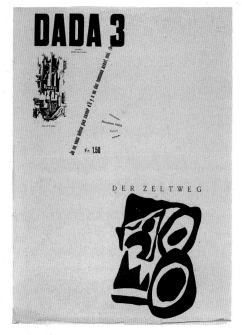

also broke numerous artistic taboos.

These were some of the heroes invoked by Breton in the first manifesto, and yet Surrealism could not have been born without the iconoclasm of radical pre-war art movements such as Cubism, Expressionism, Vorticism, Futurism and especially Dada. Founded in Zurich in 1916 by a group of writers and poets who had all converged on neutral Switzerland to escape the war, Dada was dedicated to acts of provocation and revolt. It incited violent protest against all accepted values, whether in society, morality, politics, literature or art. Even its name was chosen at random and defied meaning, translating from the French as 'hobby horse' and from Romanian as 'yes, yes'. As the British Surrealist David Gascoyne later explained:

> It spat in the eye of the world ... To many intelligent men at this time suicide seemed to be the one remaining solution to the problem of living, and Dada was a spectacular form of suicide, a manifestation of almost lunatic despair.

The founding members of the Zurich group were the Romanians Tristan Tzara and Marcel Janco, the Germans Hugo Ball and Richard Huelsenbeck and the Alsatian Hans Arp. In 1916 these founding members established the Cabaret Voltaire, a café where they organised Dada exhibitions and events, protests and pamphlets. Soon the Dada spirit spread all over Europe and breakaway groups were formed in Berlin, Cologne, Barcelona and Paris. Dada even spread across the Atlantic to New York, where it was kept alive by the artists Man Ray, Francis Picabia (1879–1953) and Marcel Duchamp (1887–1968). Duchamp himself performed the ultimate Dada gesture by exhibiting a urinal, entitled *Fountain*, at the New York *Salon des Indépendants* in 1917 (see page 7).

Littérature and the '*époque de sommeils*'

Many date the beginnings of Surrealism to a periodical called *Littérature*, which was founded by the writers André Breton, Louis Aragon and Philippe Soupault (1897–1990) in Paris in 1919. Their editorial team, led by Breton, was joined shortly afterwards by another young writer, Paul Eluard. The periodical's sarcastic title betrays a defiant attitude towards 'official', or culturally sanctioned, literature. Fuelled by the all-

↑
Dada 3 November 1918
Dada review edited by Tristan Tzara; illustration by Hans Arp

→
A session of automatic writing at the Bureau of Surrealist Research 1925

↗↗
Paul Eluard and Man Ray
Facile 1935
Paris, G.L.M. 1935

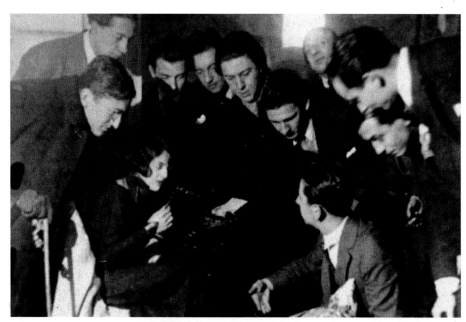

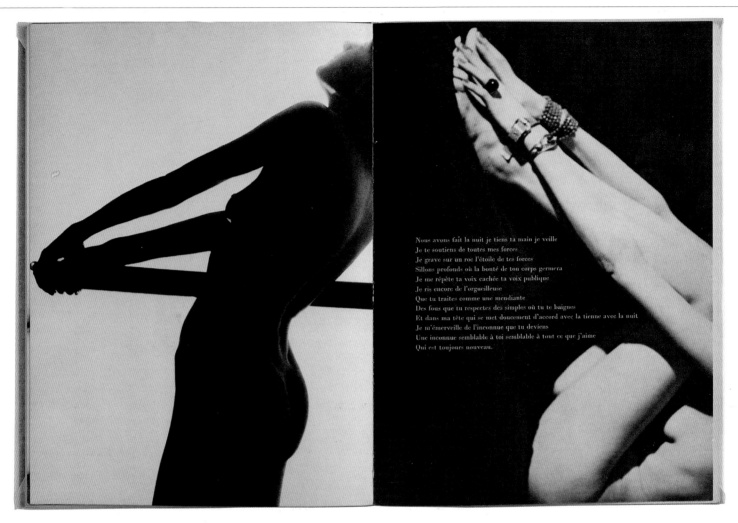

Nous avons fait la nuit je tiens ta main je veille
Je te soutiens de toutes mes forces
Je grave sur un roc l'étoile de tes forces
Sillons profonds où la bonté de ton corps germera
Je me répète ta voix cachée ta voix publique
Je ris encore de l'orgueilleuse
Que tu traites comme une mendiante
Des fous que tu respectes des simples où tu te baignes
Et dans ma tête qui se met doucement d'accord avec la tienne avec la nuit
Je m'émerveille de l'inconnue que tu deviens
Une inconnue semblable à toi semblable à tout ce que j'aime
Qui est toujours nouveau.

pervasive Dada spirit, it set out to snub traditional literary forms and subjects, and to reinvigorate the French language. Influenced by Lautréamont's phrase 'Plagiarism is necessary. Progress implies it' and by Apollinaire's poetry, Breton began to write 'collage-poems' made entirely from 'bits of ads alternating with stock phrases'. These were published alongside Lautréamont's risqué *Poésies* and Tzara's enigmatic poetry and nihilistic Dada manifesto. But it was Breton and Soupault's ground-breaking 'automatic' texts that marked a new direction for the group.

Several members of the nascent Surrealist group came from medical backgrounds. Aragon and Breton met during the war while studying at the Val-de-Grâce auxiliary hospital outside Paris, which treated patients suffering from shell-shock. There they discovered a mutual passion for poetry, particularly for Rimbaud, Mallarmé and Apollinaire, as well as a fascination for the psychiatric techniques used to treat patients, which included free association and dream analysis. Although the writings of Sigmund Freud (1856–1939) were unavailable in French translation until 1922, Breton and Aragon were aware of developments in Freudian psychoanalysis from summaries in the writings of other psychiatrists such as the French pioneer Pierre Janet. Their discovery of free association and dream analysis, which they linked to the hallucinatory or opium-induced visions of the Romantic poets, was enough to open the door to a new style of poetry, which came directly from the unconscious.

Breton and Soupault first began to experiment with 'automatic' techniques of writing in 1919 when, in an intense burst of activity, they produced *Les Champs magnétiques (The Magnetic Fields)*. As Breton described in the first manifesto:

I resolved to obtain from myself what one seeks to obtain from patients, namely a monologue poured out as rapidly as possible, over which the subject's critical faculty has no control – the subject himself throwing reticence to the winds – and which as much as possible represents *spoken thought*.

The results were a series of extraordinary,

↑
Man Ray
The Surrealist group in the Bureau of Surrealist Research
1924
Back row, left to right: Jacques Baron, Raymond Queneau,
André Breton, Jacques-André Boiffard, Giorgio de Chirico,
Roger Vitrac, Paul Eluard, Philippe Soupault, Robert
Desnos, Louis Aragon. Front row: Pierre Naville, Simone
Breton, Max Morise, Marie-Louise Soupault

→
La Révolution surréaliste no. 1, December 1924

hallucinatory texts, which bore similarities to the stream-of-consciousness literature of contemporary writers James Joyce and Virginia Woolf.

In 1920 Dada came to Paris with the arrival of Tristan Tzara. It was immediately embraced with great excitement by the *Littérature* group, and the periodical became its mouthpiece. The season of Dada events began with a flamboyant matinée at the Palais des Fêtes in January 1920. The event was intended to provoke a scandal and, like many Dada evenings that followed, ended in a brawl. Dada became a fashionable spectacle, but Breton and other members of the *Littérature* group soon began to tire of its incessant negativity and wished to channel their aesthetic discoveries in a more concrete direction. In February 1922 *Littérature*'s association with Dada came to an end with a dramatic rupture between Breton and Tzara. With typical imperiousness Breton declared: '*Lâchez tout*' (Drop everything), which unequivocally advocated 'Drop Dada'.

In September 1922 *Littérature* was relaunched as a new review that included more illustrations by artists involved with the group, particularly Francis Picabia, Man Ray and Max Ernst, and placed greater emphasis on dream narratives and hypnosis. There was less input from older writers and contributions from newcomers such as René Crevel, Benjamin Péret, Marcel Duchamp, Max Morise and Robert Desnos. The magazine included regular accounts of dreams, which were viewed as a ready means of tapping into unconscious thought, but the group was also on the lookout for other routes to the irrational. René Crevel told the other members about his experience of visiting a medium, and soon demonstrated his own ability to fall easily into trances. Regular gatherings were held at Breton's studio, described in a letter by Breton's wife Simone:

It's dark. We are all around the table, silent, hands stretched out. Barely three minutes go by and already Crevel heaves hoarse sighs and vague exclamations. Then he begins telling a gruesome story in a forced, declamatory tone...

While Breton and Soupault's collaboration on *Les Champs magnétiques* had shown the possibilities of 'automatic' writing, these new experiments produced a spontaneous verbal automatism. Of the few who managed to fall into a trance, Crevel and Desnos were the most successful. Desnos, whom Breton later described as having 'perhaps got closest to the Surrealist truth', stunned everyone with his extraordinary verbal facility and imagination while allegedly in a trance. Other members of the group contented themselves with alternative means of 'disordering the senses', such as collaborative games, nonsense verse, ironic or subversive amendments to existing texts and endless spoonerisms or wordplays. There were also a number of important publications during this period, including Paul Eluard's *Mourir de ne pas mourir (To Die from Not Dying)* (1924) and Louis Aragon's *Le Libertinage (The Libertine)* (1924).

For some months the *Littérature* group

continued to explore the world of the unconscious through sleeping fits, until it began to take over all other activity, as Aragon wrote: 'Everywhere, anywhere, they fall asleep ... In the café, amid the chatter, in bright daylight, jostled on all sides'. The seances got out of control: Desnos tried to attack Eluard with a knife during a trance and other sleepers attempted to hang themselves on coat hooks. Members of the group began to have doubts about whether the 'sleepers' were genuine and, finally, Breton called proceedings to a halt.

This period of experimentation, which became known as the '*époque de sommeils*' or 'period of sleeping-fits', was described by Breton in an article for *Littérature* called 'Entrance of the Mediums' in November 1922. In this article he uses the word 'Surrealism' to describe their collective activity for the first time:

> What our friends and I mean by *surrealism* is known, up to a point. This word is not of our invention ... but we use it with a precise meaning: we are agreed it designates a certain psychic automatism, a near equivalent to the dream state, whose limits are today quite difficult to define.

The first *Manifesto of Surrealism* and *La Révolution surréaliste*

A number of different groups tried to lay claim to the neologism 'Surrealism', however Breton's ownership of the term was confirmed with the publication of his *Manifesto of Surrealism* in October 1924. Earlier that year the group had felt the need to affirm a body of communal projects, and Breton, Soupault and Aragon decided to 'write something in collaboration, a sort of manifesto of our common ideas.' The results were Breton's manifesto and Aragon's theoretical essay 'A Wave of Dreams'.

Breton's manifesto affirms the experiments of the *époque de sommeils* and gives pride of place to automatism's

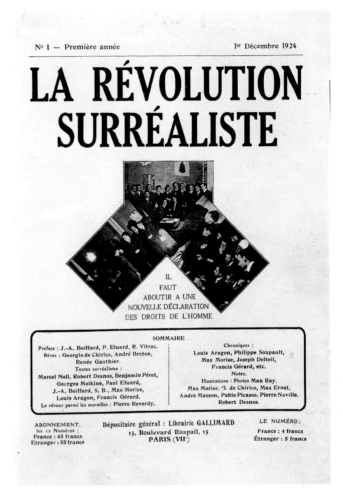

revelations of the unconscious. He argues that the world is held under the 'reign of logic', driven only by practical necessities and satisfied with mediocre realistic writing, and has lost touch with the realm of the irrational. 'The imagination has been reduced to a state of slavery', Breton wrote, and must now 'reclaim its rights'. The *pièce de résistance* is Breton's famously succinct definition:

> SURREALISM, n. Psychic automatism in its pure state, by which one proposes to express – verbally, by means of the written word, or in any other manner – the actual functioning of thought. Dictated by thought, in the absence of any control exercised by reason, exempt from any aesthetic or moral concern.

Breton also incorporates an 'Encyclopedia'

entry, in which he names those who have already performed 'acts of absolute Surrealism', and which features newcomers as well as the existing *Littérature* group. Notably, he includes no visual artists among this number except in a footnote. Furthermore, most of these were of an older generation – Seurat, Moreau, Matisse, Derain, Braque and Picasso – with only a handful of the younger artists, including Duchamp, Picabia, Man Ray, Ernst and Masson. The secondary status given to artists in the first manifesto demonstrates how long it took for the movement to assimilate both writers and artists, and it is noticeable that Breton still envisaged the products of Surrealism in terms of language.

Aragon's 'A Wave of Dreams' also

↑
André Breton, Paul Eluard, Tristan Tzara, Valentine Hugo
Exquisite Corpse 1929
Pastel on paper, 40.5 x 24.5
Moderna Museet, Stockholm

→
Giorgio de Chirico
The Child's Brain 1914
Oil on canvas, 80 x 65
Moderna Museet, Stockholm

affirms the importance of dream, chance and the imagination:

> The essence of things is in no way linked to their reality, there are relations other than reality that the mind may grasp and that come first too, such as chance, illusion, the fantastic, the dream. These various species are reunited and reconciled in a genus, which is surreality.

Aragon's list of 'members' was more inclusive than Breton's, adding girlfriends and wives, such as Simone Breton (née Kahn), as well as other writers like Antonin Artaud. With the momentum of a manifesto, the movement attracted newcomers, such as the visitors to André Masson's studio in rue Blomet, who included the writers Michel Leiris and Georges Limbour, and the painter Joan Miró.

A new movement required a new focus, and in December 1924 Breton and his friends published the first issue of *La Révolution surréaliste* (*The Surrealist Revolution*), co-edited by Pierre Naville and Benjamin Péret (see page 11). The magazine projected a deliberately factual, scientific image, although the first issue was clear enough about the Surrealists' radical intentions: 'We are on the eve of a Revolution – you may take part in it.' The first few issues focused on dream narratives and 'automatic' writing, but the magazine warned that 'we must expect everything from the future'. It also advertised a 'Bureau of Surrealist Research', set up at the suggestion of Artaud. Intended to be a 'shelter for nondescript ideas and continued revolutions', the bureau was a place where sympathisers could ask questions or contribute ideas, as well as a centre of Surrealist activity.

By 1924 the group had already been practising automatism for five years and, although it was given a central role in the Surrealist manifesto, its potential had begun to dry up. In its place, both Breton and Aragon put forward 'objective chance' and the 'pursuit of the marvellous' as new

areas for Surrealist research. These twin concepts arose out of Breton's love affair with 'the arbitrary', which he had promoted even in the early days of *Littérature*. The arbitrary was outside the realm of logic and beyond human control and had, to some extent, always been Breton's literary benchmark. It was this quality that attracted him to Lautréamont's bizarre juxtapositions and stream of consciousness prose, to dream narratives and free association, and of course to 'automatic' writing.

'Let us not mince words', Breton wrote, 'the marvellous is always beautiful, anything marvellous is beautiful, in fact only the marvellous is beautiful.' Although 'the marvellous' quickly became an all-inclusive term of affirmation in the Surrealist vocabulary, it often applied to the results of 'objective chance'. Through this process, a receptive person would be drawn to an extraordinary or bizarre occurrence that corresponded to hidden internal desires. *La Révolution surréaliste* published accounts of these occurrences, together with countless other examples of 'the marvellous', including wordplay and punning, the Surrealist game Exquisite Corpse (in which several people make up a drawing without seeing each other's contributions), accounts of conversations with 'sleepers', and descriptions of aimless wanderings around Paris. The marvellous was epitomised by the much-invoked phrase from Lautréamont's *Chants*: 'as beautiful as the chance encounter, on a dissecting table, of a sewing machine and an umbrella'.

The pursuit of the marvellous and of 'objective chance' became key topics of Surrealist research well into the 1930s and gave rise to a number of great works. Louis Aragon's novel *Le Paysan de Paris* (*Paris Peasant*) (1926) documents an aimless journey through the streets of Paris at night, where, 'in pursuit of chance', Aragon reaches an intoxicated state of wonder that he calls the 'vertigo of modern

life'. The surrender to chance also inspired Breton's liaison with an enigmatic woman in his novel *Nadja* (1928) and Philippe Soupault's detective story *Les Dernières nuits de Paris* (*The Last Nights of Paris*) (1928).

In Breton's definitive Surrealist book, *L'Amour fou* (*Mad Love*) (1937), Breton discovers another side to the 'marvellous' in the dizzying effects of love. In this book he develops his concept of 'convulsive beauty'. He describes three forms of the phenomenon: 'Convulsive beauty will be veiled erotic, fixed explosive, magic circumstantial, or it will not be.' Although it is perhaps indefinable, the concept of 'convulsive beauty', like 'objective chance', usually results from an encounter with something in the material world that corresponds to secret desires within. In *L'Amour fou* Breton's walk with his future wife, Jacqueline Lamba, through the streets of Paris at night reminds him of a poem that he had written some years before which describes the very same journey. As a result of unexpected connections and coincidences, Breton links events in the external world to unconscious desires, thereby demonstrating that the unconscious plays an active and decisive role in everyday life.

A visual surrealism

In the first few years after the publication of Breton's manifesto there was considerable debate as to whether there could be a visual equivalent to the 'pure psychic automatism' that defined Surrealism. In the very first issue of *La Révolution surréaliste* Max Morise raised some of the fundamental difficulties involved in translating active thought into a static image. Morise concluded that, in the case of the Italian painter Giorgio de Chirico (1888–1978), 'the images are surrealist but not the expression'. The debate was continued two issues later by Pierre Naville, one of the editors of the review, who wrote disparagingly:

Masters, master-crooks, smear your canvases. Everyone knows there is no

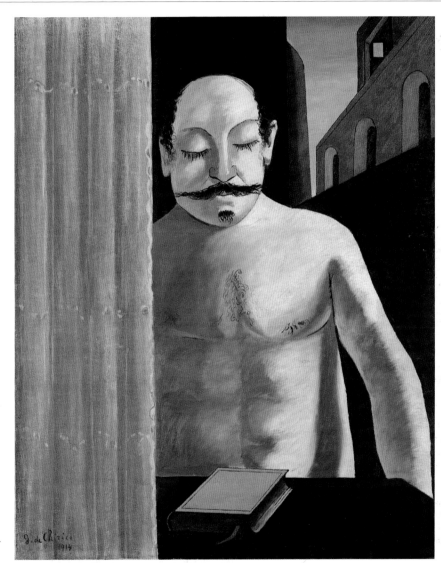

surrealist painting. Neither the marks of a pencil abandoned to the accident of gesture, nor the image retracing the forms of the dream...

Naville upheld the view that the premeditated, reflective nature of image-making necessarily entailed rational, intellectual control, negating the possibility of a pure and spontaneous flow of imagery. Breton, however, did not want to exclude the artists in whose work he had already identified a Surrealist aesthetic, and was concerned about Naville's damning indictment of a potential visual Surrealism. Shortly afterwards Breton took over the

editorship of the review, and signalled his sympathies by opening the following issue with an 'automatic' drawing. He also began to publish instalments of his major theoretical essay 'Surrealism and Painting' (*La Révolution surréaliste*, 1925–8), which included illustrations of major works by Max Ernst, Pablo Picasso, Giorgio de Chirico, Man Ray, André Masson, Joan Miró and Yves Tanguy.

'Surrealism and Painting' begins with a dramatic assertion of the primacy of vision over the other senses, but then goes on, with some degree of contradiction, to justify an equivalence between visual and verbal language:

↑↑
André Masson
Automatic Drawing 1925
Ink on paper, 24 x 32
Collection Maurice Jardot

↑
Max Ernst
Forest and Dove 1927
Oil on canvas, 100.3 x 81.3
Tate, London

The eye exists in a savage state. The Marvels of the earth a hundred feet high, the Marvels of the sea a hundred feet deep, have as their sole witness the wild eye that traces all its colours back to the rainbow ... The need to fix visual images, whether or not these images pre-exist, the act of fixing them, has exteriorised itself from time immemorial and has led to the formation of a veritable language which does not seem to me any more artificial than spoken language.

Breton ignored the problems raised by Max Morise and Pierre Naville, and insisted that painting, like poetry, was the externalisation of a 'purely interior model'. His aim was to gather certain artists under the umbrella of Surrealism, and the essay concentrates on identifying the Surrealist qualities in their work.

One of the artists first associated with Surrealism was the Italian metaphysical painter Giorgio de Chirico. Breton had first discovered his work during the First World War, when he leapt off a bus to examine a painting in a gallery window. The painting, 'whose exceptional ability to shock' had so impressed him, turned out to be de Chirico's *The Child's Brain* (1914; see page 13), which Breton later bought for his own collection. Although de Chirico never joined the movement and often disavowed the claims made by the Surrealists about his work, he visited them in Paris and enjoyed their admiration. De Chirico's bizarre juxtapositions and enigmatic settings were viewed as an equivalent to dream narratives and the flow of disparate imagery found in verbal and written automatism. But by the time of Breton's essay de Chirico was already out of favour, criticised for the loss of his early visionary powers and his return to reactionary Classical subjects.

The first artists claimed by Surrealism from the younger generation were Max Ernst and Man Ray. The discovery of Ernst's collages by the *Littérature* group in 1920 was like an epiphany. Their own poetic techniques of disruption, syntactical discontinuity and unorthodox juxtaposition were all echoed in the extraordinary cut-and-paste images of the collages. Just as Breton had included words and phrases in his poems that had been taken from advertising or from other poems, so Ernst reused images from magazines and science journals. This resulted in a disorientation of the rational world like that experienced in dreams or hallucinations. A similar quality was found in Man Ray's 'rayographs', in which familiar or everyday objects were made strange and unrecognisable through his innovative, cameraless technique. Surprisingly, rather than view photography as the ultimate 'realist' technique, Breton quickly saw its innate Surrealist potential.

Several artists attempted to find a visual equivalent to 'pure psychic automatism'. The Surrealist group initially came upon the work of the French painter André Masson (1896–1987) at his first solo exhibition at Galerie Simon in 1924. Masson's paintings combined an evocation of nature's inherent state of flux with hints of Cubist-inspired structure. In 1925 he began to experiment with automatic drawing, producing notational scribbles and doodles while in a state of trance. However the technique was not entirely 'automatic', as Masson later described:

The automatic drawing, taking its source in the unconscious, must appear as an unforeseen birth. The first graphic apparitions on the paper are pure gesture, rhythm, incantation, and as a result: pure scribbles. That's the first phase. In the second phase, the image, which was latent, reclaims its rights.

Masson became one of the pioneers of Surrealist painting by translating this twofold process into oil paint. Once again he used spontaneous, 'automatic' sketches and marks as the basis for imagery that he would then develop into the final, worked-up canvas. Masson later incorporated sand and glue into his canvases as a way of

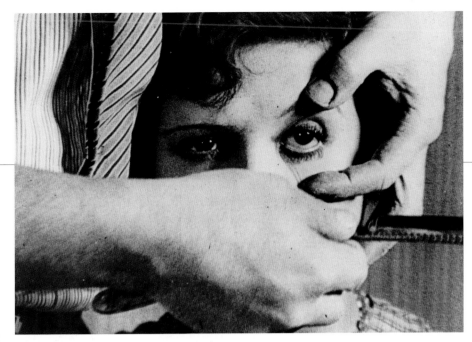

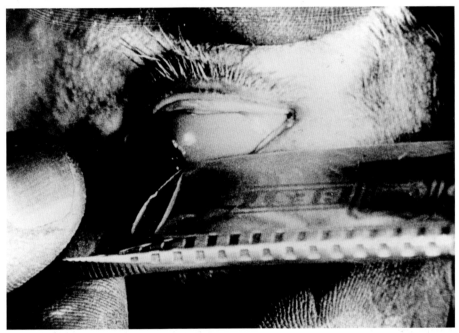

creating further arbitrary, or unconscious, elements. These methods answered Morise's call for 'automatic' techniques in painting, and were the seedbed for developments in Surrealist painting during the 1930s. Masson's neighbour in the rue Blomet was the Catalan painter Joan Miró, who was also inspired by automatic techniques. Miró's dream paintings of the mid-1920s were characterised by schematic signs and marks floating on loose open fields of colour. Aided by hallucinations caused by hunger, Miró said that his canvases arrived 'like a bolt from the blue, absolutely detached from the outer world (the world of men who have two eyes in the space below their forehead)'.

Max Ernst's extraordinary versatility as an artist is demonstrated by the variety of techniques he developed in the pursuit of Surrealist imagery. After his discovery of collage in 1919, he began to explore the possibilities of Surrealist painting. At first he worked on translating the collage method into painting, but he later developed 'automatic' techniques, such as *frottage* (rubbing) and *grattage* (scraping), followed in the 1930s by *décalcomania* (decalcomania). But just as Masson admitted that his 'automatic' imagery involved a two-fold process of unconscious and conscious activity, so Ernst developed his imagery into distinct shapes and forms, such as the disturbing 'forest' and 'horde' paintings of 1926–8.

In contrast to 'automatic' techniques, a number of artists painted images that evoked dreams or hallucinations, often using a realistic, or hyper-realistic, style. De Chirico was an important source of inspiration, especially for the French painter Yves Tanguy (1900–1955) who, like Breton, first saw de Chirico's work from the window of a bus. This event inspired him to become a painter, and he joined the Surrealist group in 1925. Tanguy's sub-aquatic or twilight landscapes (see page 16) are populated with strange biomorphic shapes that were influenced by the automatic imagery of Miró's dream paintings. The works of Belgian artist René Magritte also started out as illogical, de Chirico-inspired dreamscapes, but from the late 1920s his paintings began to reflect the movement's interest in the relationship between word and image. His deceptively simple visual conceits are reflections upon complex philosophical questions.

The arrival of Salvador Dalí in 1929 heralded a new phase of visual Surrealism, which coincided with the politicisation of the movement and its engagement with Communism. In contrast to the 'passive' techniques of early Surrealism, defined by the practice of automatism or 'objective

↑
Luis Buñuel and Salvador Dalí
Un chien andalou 1928
Film stills

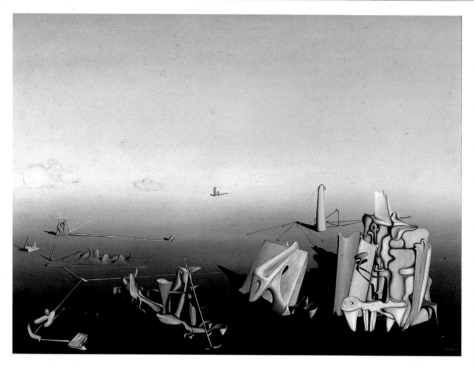

↑
Yves Tanguy
Azure Day 1937
Oil on canvas, 63 x 81.2
Tate, London

chance', Dalí introduced methods that demanded a more active role. In 1930 Dalí outlined his theory of 'paranoiac-criticism', which aimed 'to systematise confusion and contribute to the total discrediting of the world of reality'. His means were apparently realistic paintings that imitated 'paranoid' states, creating hallucinatory and irrational images of the world that induced a sense of dis-orientation and discomfort in the viewer. The paintings tested even the Surrealists' liberal attitude to sex by incorporating Freudian imagery such as masturbation and coprophilia. Dalí also collaborated with his friend the film-maker Luis Buñuel (1900–1983) on two films, *Un chien andalou (An Andalusian Dog)* (1928) and *L'Age d'or (The Golden Age)* (1930), establishing film as another important Surrealist medium.

In the 1930s the creation of Surrealist objects became an important area of activity, explored by artists and writers alike. The Surrealists had been interested in the symbolic function of objects since the mid-1920s, when regular visits to the Paris flea markets had yielded hordes of peculiar

treasures. The symbolic resonances of some of these objects are analysed in Breton's novels *Nadja* and *L'Amour fou*, where he identifies them as examples of 'objective chance' and 'convulsive beauty'. Found objects were also integral to Duchamp's 'ready-mades' – mass-produced objects, such as a urinal or a shovel, which he designated works of art. For the sculptor Alberto Giacometti, a found object provided the inspiration for sculpture: the discovery of an old gas mask in a flea market acted as a catalyst, enabling him to complete his *Invisible Object* (1934). Giacometti was a keen proponent of Surrealist objects. He wrote the theoretical article 'Mobile and Mute Objects' and created several notable works, including *Suspended Ball* (1930–1) and the enigmatic *Disagreeable Object to be Thrown Away* (1931). Dalí also took a great interest in this theme, writing several articles on the subject, as well as producing a number of striking objects, exemplified by his well-known *Lobster Telephone* (1936; see page 99). The Surrealist object was one of the areas where women artists associated with the move-ment played a particularly important role. Perhaps the most famous example is the disconcerting *Object: Fur Breakfast* (1936; see page 20), an ordinary teacup, spoon and saucer covered with suggestive animal fur, which was made by Meret Oppenheim (1913–1985) as a contribution to the exhibi-tion of Surrealist objects in Paris in 1936.

Despite the prominence of Surrealist art in the movement's journals, there was never a permanent Surrealist gallery or exhibition space. The first Surrealist exhibition was held in November 1925 at the Galerie Pierre in Paris, and there was another the following year at the Galerie Surréaliste, a temporary venue that ran from 1926 to 1928. Some artists were supported by committed dealers, but many others participated in the group exhibitions that were held at various galleries around Paris, and later internationally. The most

reliable source of Surrealist imagery and ideas remained the group's periodicals and publications. *La Révolution surréaliste* (1924–9) demonstrated a commitment to the equal representation of artists and writers, and later periodicals, such as the lavishly illustrated *Minotaure*, also reflected this trend. The flood of collaborations during the 1920s and 1930s also demonstrated the symbiotic nature of Surrealist verbal and visual production. Surrealism promoted collective action from the start, not only as a way of suppressing individual taste and choice, but also as a means of exploiting the relationship between the different disciplines. Many of these have become Surrealist classics, such as Eluard and Ernst's two early collage books, *Répétitions* (Repetitions) (1922) and *Les Malheurs des immortels* (The Misfortunes of the Immortals) (1923), Eluard and Breton's jointly written texts *L'Immaculée Conception* (The Immaculate Conception) (1930), and Eluard and Man Ray's seductive book *Facile* (1935).

Surrealism and politics

From the outset Surrealism was characterised by a spirit of revolt, but from the mid-1920s Breton's 'revolution of the mind' began to side with more mainstream political causes. This, in turn, led to schisms within the movement and to Surrealism's troubled relationship with Communism.

Shortly after the publication of the first manifesto, the group brought out a pamphlet that shocked the literary establishment. 'Un cadavre' ('A Corpse') poured insults upon the national literary hero Anatole France, who had just died. This aggressive publication caused offence to France's supporters both on the left and on the right, making the point that Surrealism was firmly opposed to any and all 'establishment' figures. However, since Surrealism was opposed to Dada's principle of scandal for scandal's sake, the group began to choose more specific social targets – primarily patriarchy,

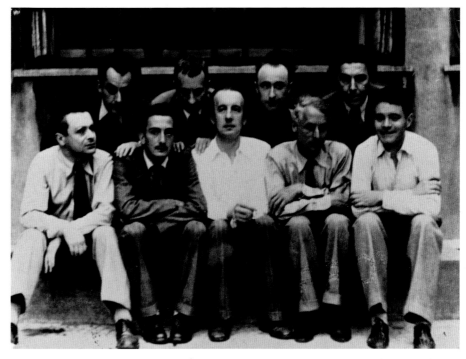

religion and morality.

The first issue of *La Révolution surréaliste* devoted a whole page to a photo-collage of the anarchist Germaine Berton surrounded by members of the Surrealist group, and the following issue included an article by Artaud with the heading 'OPEN THE PRISONS, DISBAND THE ARMY'. One of the periodical's most scandalous images was a photograph showing Benjamin Péret, perhaps the most passionately anti-establishment of the group, spitting at a priest. Further attacks on morality were made in an article called 'Hands Off Love' (*La Révolution surréaliste*, October 1927), which challenged prevailing sexual mores, and in 'Researches on Sexuality' (*La Révolution surréaliste*, March 1928), which recorded a frank conversation about sexual preferences.

In 1925 the Rif War broke out in Morocco, in which the French colonialist army tried to suppress an independent Moroccan rebellion. Many left-wing groups denounced the war, and for the first time the Surrealists felt obliged to take up a political position. They joined forces with

↑
Man Ray
Surrealists in front of Tristan Tzara's studio in Paris 1930
Musée d'art et d'histoire, Saint-Denis, Paris

↓
Alberto Giacometti
Disagreeable Object to be Thrown Away 1931
Wood, 19.6 x 31 x 29
Scottish National Gallery of Modern Art, Edinburgh

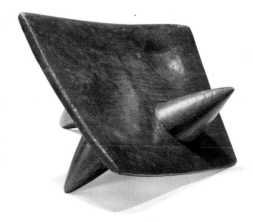

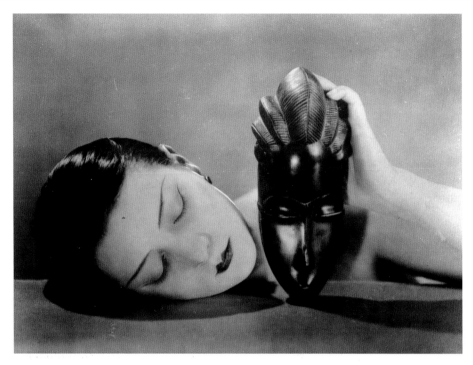

↑
Man Ray
Noire et blanche 1926
Gelatin silver print

the Communist-inclined periodical *Clarté* and denounced the war in a violently anti-patriotic manifesto called 'Revolution First and Always!', published in *La Révolution surréaliste* (October 1925). Other left-wing groups also signed the manifesto, including Camille Goemans and Paul Nougé, the editors of the Belgian review *Correspondance*. Nougé was a founder member of the Belgian Communist party and Surrealism's new political commitment made it possible for a Belgian Surrealist group to form. Breton and Aragon began to shift noticeably away from a previously sceptical attitude towards the Russian Revolution: Aragon published an article entitled 'The Proletariat Spirit' in *Clarté* and Breton wrote a favourable review of Leon Trotsky's life of Lenin. At the same time, however, Breton continued to maintain Surrealism's independent position. Although the movement was sympathetic to Marxist ideas, he was not prepared to sacrifice its artistic freedom.

In 1926 Pierre Naville, who was sympathetic to Communism, published an article called 'The Revolution and the

Intellectuals. What can the Surrealists do?', which asked: 'Yes or no, is the desired revolution that of the spirit *a priori*, or that of the world of facts? Is it linked to Marxism, or to contemplative theories, to the purifying of interior life?'. Breton responded in 'Legitimate Defence', in which he reasserted Surrealism's commitment to a proletarian revolution, with one proviso: 'It is no less necessary, as we see it, for the experiments of the inner life to continue and this, of course, without an external check, even a Marxist one.' Breton believed that to change the material condition of people's lives required a change in people's thinking, and that in this respect Surrealism's experiments with the unconscious, their 'revolution of the mind' was just as important as the preachings of Marxist dialectical materialism. However, despite their misgivings, in 1927 Breton, Aragon, Eluard, Péret and the newcomer Pierre Unik all decided to join the Communist Party.

Fresh quarrels broke out in February 1929 when Breton and Aragon distributed a questionnaire to the Surrealists and other groups sympathetic to the movement, asking whether communal revolutionary action was possible, and for them to state their position. Many of the recipients ignored the questionnaire, but at a stormy meeting Breton challenged those who attended about the purity of their commitment to Surrealist principles. He accused some of sacrificing principle to careerism, and the evening was rounded off with denouncements and dismissals. Breton's high moral position was unassailable and besides those who were expelled, such as Philippe Soupault, many others left the movement, including the 'rue du Château' group (Duhamel, Prévert and Tanguy), Jacques Baron and Man Ray.

The writers and artists associated with the 'rue Blomet' studios, including Leiris, Masson, Miró and Georges Bataille (1897–1962), were also among those who now

moved away from the movement. Forming their own group of 'dissident Surrealists' they set up a new review called *Documents*, co-edited by Bataille and Leiris. Although there had always been Surrealist splinter groups, those who now gathered around Bataille posed a serious threat to the movement's unity.

Georges Bataille, Surrealism's 'old enemy within', had been marginally involved with the movement since 1920, but although he took a keen interest in psychoanalysis and the unconscious, his interpretation differed dramatically from Breton's. Where Breton saw the possible fusion of interior and exterior worlds, of pathology and normality, Bataille was committed to the idea of 'transgression', where one disrupts the other in a precarious state of imbalance. Bataille was fascinated by ethnography and pornography, publishing the erotic novel *L'Histoire de l'œil* (*Story of the Eye*) under the pseudonym 'Lord Auch' in 1928. He explored the taboo subjects of death, sex, degradation and power, and revelled in bestiality and ugliness, which he termed '*bassesse*' (baseness).

While Bataille saw Breton's brand of Surrealism as incurably idealistic, Breton criticised Bataille's pessimism. In his denouncement of 'defectors' in the *Second Manifesto of Surrealism*, Breton makes a personal attack on Bataille:

It is to be noted that M. Bataille misuses adjectives with a passion: befouled, senile, rank, sordid, lewd, doddering, and that these words, far from serving him to disparage an unbearable state of affairs, are those through which his delight is most lyrically expressed.

In contrast to Breton's image of Surrealism as man's path to freedom, both mental and material, Bataille asserts that 'it is impossible [for man] to behave differently from the pig rooting in the slop heap'.

Breton's *Second Manifesto of Surrealism*, which was published in instalments in the last issues of *La Révolution surréaliste*, sets out to redefine core Surrealist principles within the framework of Marxist dialectical materialism. In the opening paragraph Breton writes that Surrealism 'attempted to provoke, from the intellectual and moral point of view, an attack of conscience of the most general and serious kind.' But if the first manifesto was characterised by a desire to break with old orders and defy reason, the second manifesto is preoccupied with the idea of fusion, with finding a meeting point between the interior and the exterior world. Breton writes:

Everything tends to make us believe that there exists a certain point of the mind at which life and death, the real and the imagined, past and future, the communicable and the incommunicable, the high and low, cease to be perceived as contradictions. Now, search as one may one will never find any other motivating force in the activities of the Surrealists.

In the second manifesto discussions of automatism and dream are replaced by analyses of Karl Marx and Friedrich Hegel. Breton attempts to balance, with unavoidable contradiction, Surrealism's new adherence to Marxism with a commitment to original Surrealist principles: 'Surrealism aims quite simply at the total recovery of our psychic force by a means which is nothing other than the dizzying descent into ourselves'. He is insistent that the two practices can exist side by side:

How can one accept the fact that the dialectical method can only be validly applied to the solution of social problems? The entire aim of Surrealism is to supply it with practical possibilities in no way competitive in the most immediate realm of consciousness. I really fail to see – some narrow-minded revolutionaries notwithstanding – why we should refrain from supporting the Revolution, provided we view the problems of love, dreams, madness, art, and religion from the same angle as they do.

Later on in the document Breton goes further, declaring: 'Surrealism ... has no intention of minimising Freudian doctrine as it applies to the evaluation of ideas.'

Much of the second manifesto is devoted to answering both real and imaginary accusations that, on the one hand, Surrealism had become an exclusive, authoritarian movement and that, on the other, it could not reconcile its principles with true Marxism. In the light of recent debates and dismissals, Breton also uses the manifesto as another opportunity to denounce Surrealist enemies, ruthlessly singling out former friends and allies for personal character assassination. He rounds off with the challenge: 'Is a man ready to risk everything so that at the very bottom of the crucible into which we propose throwing our very poor abilities, what remains of our reputations and our doubts ... he may have the joy of catching a glimpse of *the light which will cease to flicker*?'

In 1930 Surrealism launched a new periodical with the mollifying title *Le Surréalisme au service de la révolution* (*Surrealism at the Service of the Revolution*, shortened to SASDLR), which defined the movement's new position in relation to Marxism. The humility of the title did not allay the suspicions of the French Communist Party, however, who reacted to Breton's second manifesto with the statement: 'If you're a Marxist, you have no need to be a Surrealist.'

Despite this, Surrealist activity continued unabated and, as Breton had promised, new experiments in Freudian doctrine were published in SASDLR. The review initiated a more active phase of Surrealism. In contrast to the passive submission to dream and automatism, research now focused on actively harnessing these states, and the arrival of newcomers such as Salvador Dalí, in place of the defectors, gave the movement a new artistic impetus. As a

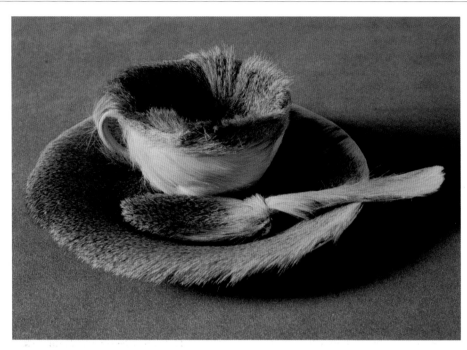

↑
Meret Oppenheim
Object: Fur Breakfast 1936
Fur-covered cup, saucer and spoon, 7.3 x 23.7
The Museum of Modern Art, New York. Purchase 1946

counterpart to Dalí's 'paranoiac-critical' method, Breton and Eluard worked on jointly written texts that simulated disturbed psychological states such as delirium, mania and paranoia. These were published in a volume called *L'Immaculée Conception* in 1930.

Aragon's literary sympathies were, however, moving in another direction, towards narrative and proletarian literature. Political tensions within the movement reached their peak in 1932, when Aragon and Georges Sadoul were invited, as official representatives of Surrealism, to join the second International Conference of Revolutionary Artists and Writers at Kharkov in the USSR. There they found themselves outnumbered by official Communist representatives and, faced with the threat of being excluded from defining the new revolutionary literature, they signed a letter that repudiated Breton's second manifesto and condemned idealism, Freudian psychoanalysis and Trotskyism, which were all fundamental principles of Surrealism.

On returning to meet Breton's wrath, Sadoul and Aragon pleaded duress and

escaped expulsion, but Aragon's position had shifted definitively towards greater political activism. That same year he published the militant propagandist poem 'Front Rouge' ('Red Front') in the review *Literature of World Revolution*. The review was seized by the police and, on account of the inflammatory line 'Kill the cops', Aragon was prosecuted for inciting violence and 'provoking insubordination in the army'. Despite Breton's undisguised loathing of the poem, he and the Surrealists set up a petition of protest arguing, rather ironically given Surrealism's revolutionary mission, that 'legal significance' could not be attributed to a poem. Although the charges against Aragon were subsequently dropped, the 'Aragon Affair' sparked furious debate, and the Communists regarded Breton's defence as an untenable position for a revolutionary. Aragon sided with the Communists and in 1932 he finally decided to leave Surrealism.

Aragon had been Breton's closest friend and ally, and his departure was a terrible blow to him. Despite this, Breton refused to submit Surrealism to the control of politicians and, taking up a Trotskyist position, he maintained that art can only succeed in being truly revolutionary if it is independent of political concerns. However, in the growing climate of Fascism, the Surrealists came under greater pressure to join forces with the Communist Party and further attempts at joint action were undertaken. This continued until 1934, when Trotsky was deported from France and the Surrealists saw that there could be no union between their position and Stalinism. In 1935 links between Surrealism and Communism were severed definitively when they were expelled from the Party. It marked the end of what became known as the 'heroic' period of Surrealism, a period defined by friendships, possibility and unmitigated idealism.

Postscript: an international movement

The meanderings of the Surrealist movement after 1935 are as complex as the movement's origin. This is partly because the movement had no official end, although André Breton, its guide and mentor, died in 1966. Surrealism's break with Communism in 1935 marked a turning point, however, because in the tense political climate that led up to the Second World War, the movement fragmented and diversified. Those who had left or been expelled were replaced by many new adherents, some of whom were refugees escaping the tightening clutch of Fascism and others who were drawn by the magnet of the movement's growing reputation. The 1930s saw the increased international standing of Surrealism, aided by numerous lecture tours conducted by Breton and by international reviews and periodicals which produced specialist Surrealist issues. The movement's ideas and imagery were also disseminated through several landmark exhibitions both in France and abroad. But as Surrealism's popularity and diversity grew, it inevitably developed a life of its own, outside and beyond the basic tenets of the movement's origin.

The surge of new members to the Surrealist group during the 1930s came from all over the world. Some of these artists and writers had already been associated with the movement, others had not, but all enriched it with new themes and styles. Among them was the Czech Surrealist group, which was founded in 1934 by writers Karel Teige and Vitězslav Nezval, and included the painters Jindřich Styřský, Toyen (Marie Čermínová) and Josef Síma. They joined other painters such as the Romanians Jacques Hérold and Victor Brauner, Oscar Domínguez from Spain, Wifredo Lam from Cuba, Kurt Seligmann from Switzerland, and Roberto Matta from Chile, who all contributed to a dynamic new wave of Surrealist painting. The 1930s saw a closer connection with the *Documents* group, through the journal *Minotaure*, bringing the new artists associated with this group closer to mainstream Surrealism. These included the photographer Jacques-André Boiffard, the painter Balthus (Balthasar Klossowski de Rola) and the sculptor and photographer Hans Bellmer.

Despite Surrealism's ambivalent attitude towards women, several female artists became prominent within the group during the 1930s. Although the movement espoused sexual and spiritual liberation, in practice conventional mores often prevailed and women were relegated to the traditional roles of muse or object of desire. However, the Surrealist milieu did provide relative sanctuary for many women, and several found it possible to develop their own careers as artists and writers. The American artist Lee Miller pioneered the photographic technique of 'solarisation' with Man Ray before developing a career as an international reportage photographer. Claude Cahun began to use photography in the late 1920s and made a series of theatrical, gender-crossing self-portraits. Meret Oppenheim also worked with photography, participating in some of Surrealism's most memorable erotic images, and, together with Gala Eluard and Valentine Hugo, was an exponent of Surrealist objects. Several women contributed to the development of Surrealist painting in the lead up to the Second World War, notably the British artists, Ithell Colquhoun, Eileen Agar and Leonora Carrington, the American Dorothea Tanning and the Frenchwomen Jacqueline Lamba and Valentine Hugo. The Mexican artist Frida Kahlo is also recognised for her unique contribution to Surrealist painting.

Surrealism's fame was punctuated by a number of key international exhibitions. It was first introduced to the American public through a group exhibition at the Wadsworth Athenaeum in 1931–2, organised by a shrewd young gallery-owner called Julien Levy. The exhibition included Dalí's famous 'soft watches' painting *The Persistence of Memory* (1931) which became an instant hit. By the time Dalí arrived in New York in 1934 it had already been sold to the Museum of Modern Art, ensuring Dalí's position in America as the pre-eminent Surrealist artist.

In 1936 the director of the Museum of Modern Art organised a ground-breaking exhibition called *Fantastic Art, Dada, Surrealism* which stamped the seal of approval on Surrealism once and for all. The movement's success in America swiftly led to its commercialisation, however, and despite Breton's disapproval, artists such as Dalí were quick to cash in on their new-found fame. To Breton's frustration, Surrealism became known as an eccentric artistic movement divorced from the social and political experiments that determined its genesis.

The movement's fame also spread to Britain, advertised by an exhibition of Surrealist art at the Burlington Galleries in London in 1936. The exhibition was organised by Roland Penrose, a British artist and collector who was a close friend of Dalí, the Belgian Surrealist E.L.T. Mesens and David Gascoyne, a young British poet. It showed a wide range of work by the key figures of the movement, but also included local contributions. Further elucidation for the sluggish British public was provided in Gascoyne's excellent book *A Short Survey of Surrealism* (1935), written when the author was still only nineteen years old, and in the recently founded *International Bulletin of Surrealism*.

The most important Surrealist exhibition of the 1930s, however, was held in Paris at the Galerie des Beaux Arts in 1938. The exhibition included all the major artists associated with the movement over the previous fifteen years, combining works by the earlier generation (Picasso, de Chirico, Picabia and Duchamp) and the middle generation (Ernst, Masson, Miró,

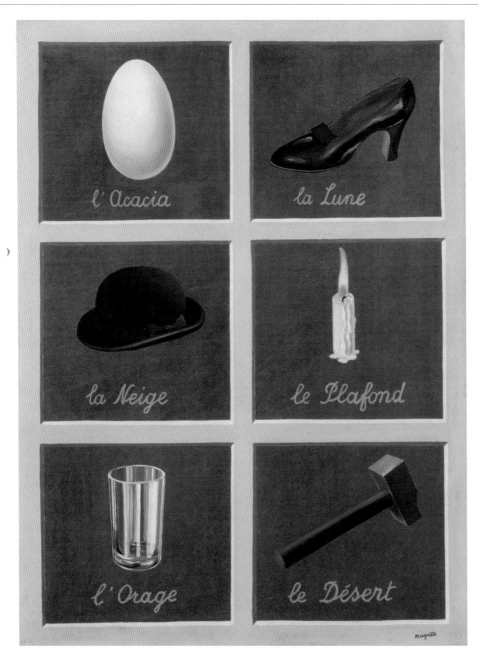

↑
René Magritte
The Interpretation of Dreams 1930
Oil on canvas, 81 x 60
Private Collection

Man Ray and Tanguy) with more recent Surrealist recruits (Brauner, Domínguez and Bellmer). Duchamp orchestrated an elaborate and disorientating exhibition environment that included a floor strewn with leaves and branches, coal sacks hoisted to the ceiling, which distributed a fine layer of coal dust on the visitors, and an eerie recording of hysterical laughter.

The political climate in the years leading up to the Second World War also contributed to the fragmentation of the movement, and it became increasingly difficult for the Surrealists to maintain a coherent political position. Despite the group's quarrels with Communism, many members viewed it as a way to unite with others in the fight against the rising tide of Fascism. The outbreak of the Spanish Civil War in 1936 mobilised left-wing intellectuals across Europe. Joan Miró exhibited his defiant painting *Reaper* alongside Picasso's *Guernica* at the Spanish Republican Pavilion in the 1937 Exposition Universelle in Paris, and despite Surrealism's strongly pacifist stance, Benjamin Péret went to fight in Spain. Eluard's growing concern about Fascism brought him closer to Communist groups, and he began to write politically engaged poetry about freedom and struggle. He broke with Breton in 1938 and finally rejoined Aragon and the Communist party in 1942. Breton, however, moved closer to Trotsky and during a meeting in Mexico in 1938 they collaborated on a manifesto called 'For an Independent Revolutionary Art'. Such was Breton's isolation that he was one of the few to denounce the Moscow show trials of 1936, which Stalin used to purge the party of detractors.

The outbreak of the Second World War polarised positions even further, creating an insurmountable breach between those who spent the war in exile and those who went to fight or remained in occupied France. Péret and Leiris were mobilised, while Aragon and Eluard were among

those who stayed behind, both becoming active members of the French underground resistance. Many of the others chose exile, mostly converging on New York or Latin America. Magritte and Nougé remained in Brussels and Miró retreated to the relative safety of Palma in Spain.

In New York Breton, Duchamp, Masson and Ernst continued Surrealist activities, holding exhibitions and publishing reviews for an enthusiastic American public, but when they returned to Europe they found a gulf of difference between themselves and those who had experienced the war first hand. The intellectual climate had also changed: Communist writers dominated the literary scene and Breton found himself up against a new intellectual giant, Jean-Paul Sartre. Breton continued to lecture, initiate reviews and plan exhibitions, but he also began a period of consolidation: he revised previous texts, published new editions of classic works and even wrote a history of the movement. The post-war years saw many attempts to resuscitate Surrealist activities, but the group struggled to find a sense of unity and purpose. There was an insurmountable gulf of time between the new young adherents and the veteran members of the group, and while the Paris-based Surrealists grouped around Breton still emphasised the political motivation of the movement, for many others Surrealism had taken on new meanings. Surrealist politics and poetics had diverged irrevocably, and new artistic currents inevitably took over.

Most artistic movements eventually burn themselves out but it is testament to the enduring spirit of Surrealism that it not only lasted as an official movement for over forty years, but is also still an important influence on art today. From the very beginning, emerging from the carnage of the First World War, Surrealism demonstrated a rigorous faith in the possibility of changing life, and pursued this end with unswerving determination. The backbone of the movement was the members' unshakeable idealism, providing a framework that could encompass many diverse styles, interests and personalities. Surrealism thrived on an exchange of ideas and, as part of its challenge to prevailing social structures and traditional areas of artistic practice, it turned to new fields of research, such as psychoanalysis, linguistics and anthropology. Artists and writers, dreamers and politicians, fighters and pacifists, all contributed to the richness of the movement. Surrealism defined a new intellectual arena, offering 'the seductions of the marvellous, the landscapes of dreams, the space of thought set free'.

↗
Man Ray
Paul Eluard (detail) 1935

↗↗
Man Ray
Max Ernst (detail) 1934

Paul Eluard & Max Ernst
The impact of collage

Of the many collaborations, allegiances and subsequent betrayals that characterised Surrealist group politics, the friendship between the artist Max Ernst and the poet Paul Eluard was one of the most steadfast. When they first met, in 1921, Surrealism as a movement had not officially been established and Dada still reigned supreme in Paris. Like many of the artists and writers associated with Surrealism, Eluard and Ernst were both scarred by the experience of the First World War. Both men had been involved in frontline battle and discovered later that they had fought on opposing sides at the Battle of Verdun in 1917. 'Three years later', Eluard wrote, 'we became the best friends in the world, and ever since, we have been relentlessly fighting for the same cause, that of man's total emancipation.'

For Eluard and Ernst, as for many others, the only sense that could follow the nonsensical horrors of war was the nihilism of Dada. In 1920 Tristan Tzara, the founder of Dada in Zurich, arrived in Paris, where he set up the new Dada head-quarters. Breton and the other writers associated with the proto-Surrealist magazine *Littérature* eagerly embraced Dada's aggressive challenge to traditional values. Eluard played an active part in many of the Dada events, including the provocative Festival Dada at the Salle Gaveau in May 1920, where he slashed coloured balloons inscribed with the names of establishment figureheads with a butcher's knife.

Soon Eluard's naturally lyrical poetry also began to reflect the Dada spirit. Along with the other *Littérature* writers, Eluard wanted to break down the boundaries of conventional literature and revitalise language as a radical and subversive force. Since 1919 the group had been experimenting with automatic writing, a technique designed to bypass conscious control and produce writing that reflected the vagaries of thought and dream. Free association, collaborative word games and poetry littered with quotation were among the techniques they used to subvert traditional expectations of literature. They looked to earlier writers such as Guillaume Apollinaire, who had paved the way with his ground-breaking poem 'Monday on Rue Christine', which consisted entirely of overheard fragments of café conversation. Similarly Tzara had claimed that the way to make a Dada poem

was to cut up a newspaper with a pair of scissors. As these examples demonstrate, the principle of collage – or cut-and-paste – was fundamental to the nascent Surrealist poetics.

In 1920 the Paris Dada group was introduced to the works of Max Ernst, an event that Breton later described as a 'revelation'. 'I remember very well the occasion when Tzara, Aragon, Soupault and I first discovered the collages of Max Ernst,' Breton recalled. 'We were all in Picabia's house when they arrived from Cologne. They moved us in a way we never experienced again. The external object was dislodged from its usual setting. Its separate parts were liberated from their relationship as objects so that they could enter totally new combinations with other elements.' In Ernst's collages the writers discovered a visual technique that was remarkably similar to their own experiments with language, and immediately brought to mind the unexpected juxtapositions that characterised the poetry of their hero, the Comte de Lautréamont. For the first time it was possible to see a visual equivalent to the technique of automatic writing, and the group immediately invited Ernst to exhibit in Paris.

As a German, Ernst was refused an entry visa to France but his exhibition, *Beyond Painting*, was held at the Galerie Au Sans Pareil in May 1921. It was the first significant move towards a visual art that was eventually characterised as 'Surrealist'. The term 'collage' had barely been invented, and although Ernst's new cut-and-paste technique was clearly linked to Picasso's and Braque's Cubist *papier collé* (pasted paper) works of the 1910s, he was moving in a new direction. Picasso and Braque mixed painted imagery with physical objects as a way of bringing the 'real' world into the painting and suspending the illusionism of the painted surface. Ernst went further and wished to turn away from the medium of painting altogether. He wanted to challenge the idealist aesthetic that had become attached to painting as well as the importance placed on the artist's creative gesture. As an alternative he chose to work in a manner that was closer to the labour-intensive process of craft techniques, patiently cutting and sifting existing printed material into unexpected new configurations. Illustrations from nineteenth-century romances collided with diagrams from technical manuals, and biological drawings merged with advertising imagery. In a

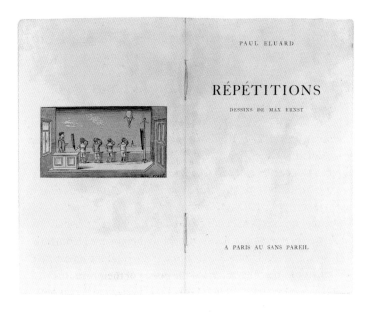

preface to the exhibition Breton wrote of Ernst's 'wonderful faculty of reaching, without leaving our field of experience, two distinct realities and, by bringing them together, of producing a spark'. This description was to form the backbone of Breton's definition of Surrealism in the first manifesto of 1924 and became the key principle behind the Surrealist concepts of 'convulsive beauty' and 'the marvellous'. It is not surprising that Ernst was one of the few artists to be included in Breton's first *Manifesto of Surrealism*.

Eluard was also tremendously excited by Ernst's 'collages' and travelled with his wife, Gala, to meet the artist in Cologne in November 1921. They became immediate friends and spent the autumn planning a book of poetry for which Ernst was to contribute illustrations. The result was *Répétitions* (*Repetitions*), which was published the following year and became the first of their many collaborative projects. That same year, they jointly wrote the prose poems for a second volume, *Les Malheurs des immortels* (*The Misfortunes of the Immortals*). Ernst and Eluard worked together on more than six projects, reflecting their shared belief in the value of collective activity and invention.

In 1922 Ernst left Germany for good. He used Eluard's passport to smuggle himself across the border and moved in with Eluard and Gala at their home north of Paris. Ernst had been captivated by Gala when they had met the previous year, and the group soon established a celebrated *ménage à trois*. Eluard and Gala had married when they were both very young and quickly discovered that their voracious sexual appetites were not suited to the monogamy of a conventional relationship. However, although Eluard's love poetry was fuelled by his idealisation of women, Gala remained his most constant muse. Their open marriage tolerated many affairs until Gala fell in love with Salvador Dalí in 1929. Yet Eluard continued to express his eternal love and longing for her long after they had both remarried.

Ernst and Eluard were pivotal figures of the Surrealist movement, and were among those who remained closest to Breton despite the many ruptures and schisms with other members. Eluard was one of the group's most prolific writers and has become known as one of France's greatest lyric poets of the

↑
Répétitions 1922
Frontispiece and title page
Gabrielle Keiller Collection, Scottish
National Gallery of Modern Art, Edinburgh

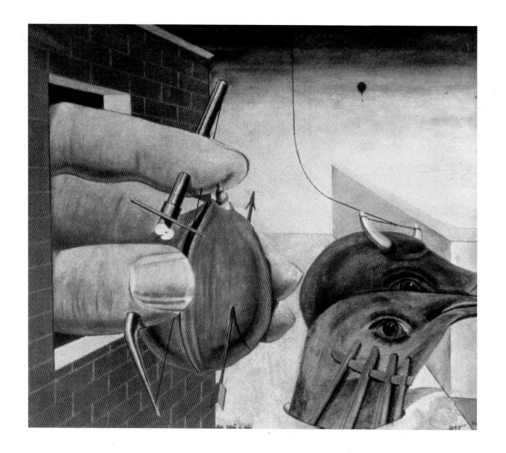

↑
Max Ernst
Oedipus Rex 1922
Oil on canvas, 93 x 102
Private collection

↗
Max Ernst
Pietà or Revolution by Night 1923
Oil on canvas, 116.2 x 88.9
Tate, London

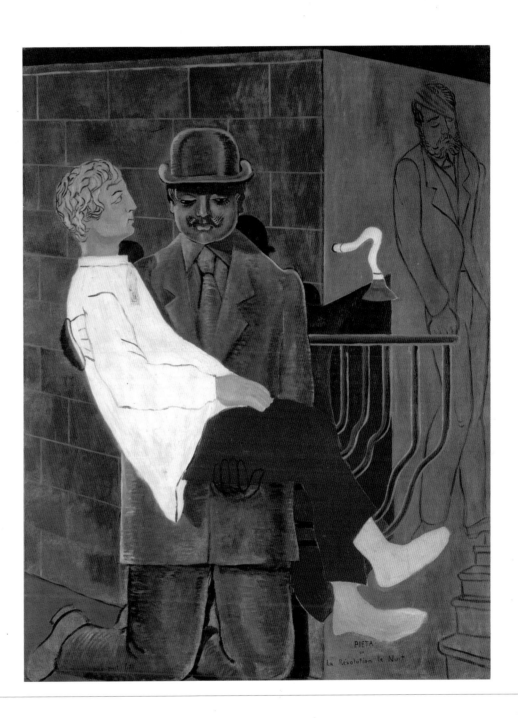

twentieth century. His love poetry uses simple, everyday language to express an idealistic faith in love and human relationships. Like other members of the Surrealist group, he joined the Communist Party in 1927 and grew steadily more political, which eventually resulted in his definitive break with Surrealism in 1938. He later achieved national recognition for his role in the French Resistance during the Second World War, and his famous patriotic poem 'Liberty' was leafleted over occupied France to boost morale.

Ernst played an instrumental role in the development of an aesthetic of Surrealism. Before his arrival many members of the group doubted the possibility of producing a visual equivalent to their experiments in free association and automatic writing. After the 'revelation' produced by his collages, Ernst went on to translate this technique into painting. During Eluard's visit to Cologne in 1921, he bought Ernst's *Pietà or Revolution by Night* (1921) and *Oedipus Rex* (1921), which are now regarded as being among the first Surrealist paintings. In the imagery of these works the French writers discovered that Ernst shared their fascination with the writings of Sigmund Freud and had also been influenced by the art of the mentally ill. Before the war Ernst had studied psychiatry, philosophy and history of art at the University of Bonn, and he had first read Freud in 1913, long before the works were translated into French.

Collage, which may loosely be described as the overlapping or linking of unrelated material, was the key principle behind early experiments in both Surrealist poetry and visual art, but Ernst went on to develop other techniques allied with the progression of Surrealist ideas. In 1925 he claimed to have 'discovered' the technique of *frottage* ('rubbing'). By placing paper over an object or material, such as wood, string or cloth, and rubbing it with a pencil, unexpected shapes begin to appear on the paper. The technique was inspired by a childhood memory of seeing organic shapes appear in the patterns of a mahogany panel by his bed. Ernst considered it to be equivalent to automatic writing because it reduces the conscious intervention of the artist and lays the image open to chance. *Frottage* found a counterpart in painting as *grattage* ('scraping'), where paint is scraped from a canvas to leave an imprint of the object placed underneath. These

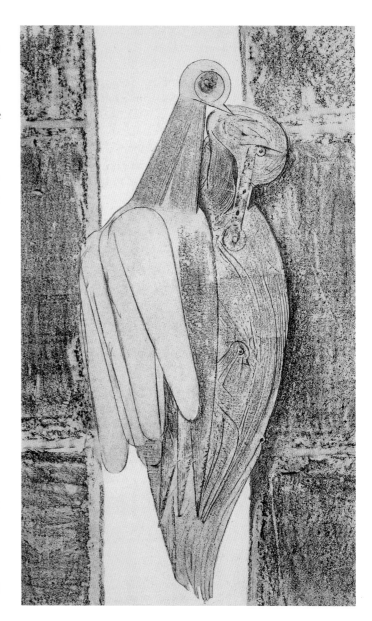

↑
Max Ernst
Conjugal Diamonds 1925
Illustration from *Histoire Naturelle*
Paris 1926
Gabrielle Keiller Collection, Scottish
National Gallery of Modern Art, Edinburgh

techniques, together with *décalcomania* (decalcomania) – in which
tacky paint is pressed between two layers of paper or canvas that
are then separated to reveal suggestive shapes – were the found-
ation for much of Ernst's later work. From the 1930s his paintings
became increasingly fantastical: overgrown forests, jungles and
futuristic cities are the key motifs of his mature period. He did,
however, return briefly to the collage technique in the late 1920s
and early 1930s to produce three 'collage novels', including *La
Femme 100 têtes* (*The Hundred-Headed Headless Woman*) (1929). In 1938,
as a result of Breton's call to ostracise Eluard, Ernst temporarily
left the movement.

↑
Max Ernst
The Sheep 1921
Illustration for *Répétitions*, Paris 1922
Collage and gouache, 11.2 x 16
Musée national d'art moderne,
Centre Georges Pompidou, Paris

The Sheep Paul Eluard

Close your eyes black face
Close the gardens of the street
Intelligence and hardiness
Ennui and tranquillity
These sad evenings at every moment
The glass and the glass door
Comforting and sensible
And light, the fruit-tree
The flowering tree the fruit-tree
Fly away.

The Word Paul Eluard

I have easy beauty and it's good
I slide along the roof of the winds
I slide along the roof of the seas
I have become sentimental
I no longer know the guide
I no longer move silk on the ice
I am ill flowers and stones
I love the most chinese to the naked heights
I love the most naked eluding bird-like
I am old but here I am beautiful
And the shadow which descends from the dark windows
Saves each evening the black heart of my eyes.

↑
Max Ernst
The Word (Bird-Woman) 1921
Illustration for *Répétitions*, Paris 1922
Collage and gouache, 18.5 x 10.6
Private collection

After the earth-shattering experience of the First World War, for many artists the only conceivable kind of art was one that echoed the fragmentation and arbitrariness of the world outside. The cutting and splicing of collage was the natural product of a world of severed limbs and disrupted lives. It was in this climate of rebellion and frustration that Max Ernst and Paul Eluard produced the small volume of poems with collage illustrations called *Répétitions*.

When Ernst's collages and drawings were first displayed at his exhibition in Paris in 1921, Eluard was quick to see the importance of these strange, disjointed images, and recognised a parallel in his own attempts to challenge and revitalise language. He later summarised:

> About 1919, when imagination was attempting to dominate and contain those dismal monsters that war had strengthened, Max Ernst decide to bury ancient Reason – the cause of so much disaster – not under the ruins of their own monuments, but under a liberated representation of a liberated world.

Much of the imagery in *Répétitions* implies a rejection of old school values, particularly those associated with learning and training: the frontispiece for the volume is a sarcastic image showing a Prussian schoolroom with children engaged in a rigorous drill or salute. The volume may also be seen as a virtual manifesto for the practice of collage. Its title suggests the elaborate reusing and overlaying of the collage process, as well as the repetition of learning, and the poems and collages themselves advertise the incredible freedom of this revolutionary new technique.

'The Word' shows Ernst and Eluard presenting a new world order. In the collage man has turned his back, while woman is seen rising from an open brain, as if in parody of Venus rising from the waves. For the Surrealists woman was associated with the imagination, an image intensified by the presence of birds, which are naturally associated with flight and freedom. Eluard's poem invokes an absent woman, who is described as 'bird-like', while Ernst presents a naked headless woman with a bird tucked under her arm and another peeping between her legs. The new world, these images suggest, is one governed by the freedom of the imagination, and this is represented by woman.

The collage technique provided the perfect vehicle for disrupting accepted orders and hierarchies. In 'The Word' Ernst contrasts an idealised female nude in a Classical *contrapposto* pose with scientific images of muscular patterns in the female thigh, taken from a medical textbook. Ernst deliberately confuses different registers of thought – art and science – as a way of questioning traditional taxonomies, or modes of categorisation.

Eluard's mysterious poem at first challenges the reader to make any sense of it at all. In the original French, however, feminine adjectives reveal the speaker to be female. The French title is also a feminine noun, '*la parole*', meaning 'the word', and suggests that the poem is describing the role of words and language. Following this reading, Eluard presents language as something elusive and slippery: it is without a 'guide' and 'slides on the roof of the winds'. Eluard breaks down traditional syntax and teases the reader who tries to make coherent sense of the poem. Like Ernst's unexpected juxtapositions, Eluard creates a verbal collage that defies accepted grammatical rules and challenges traditional expectations of literature.

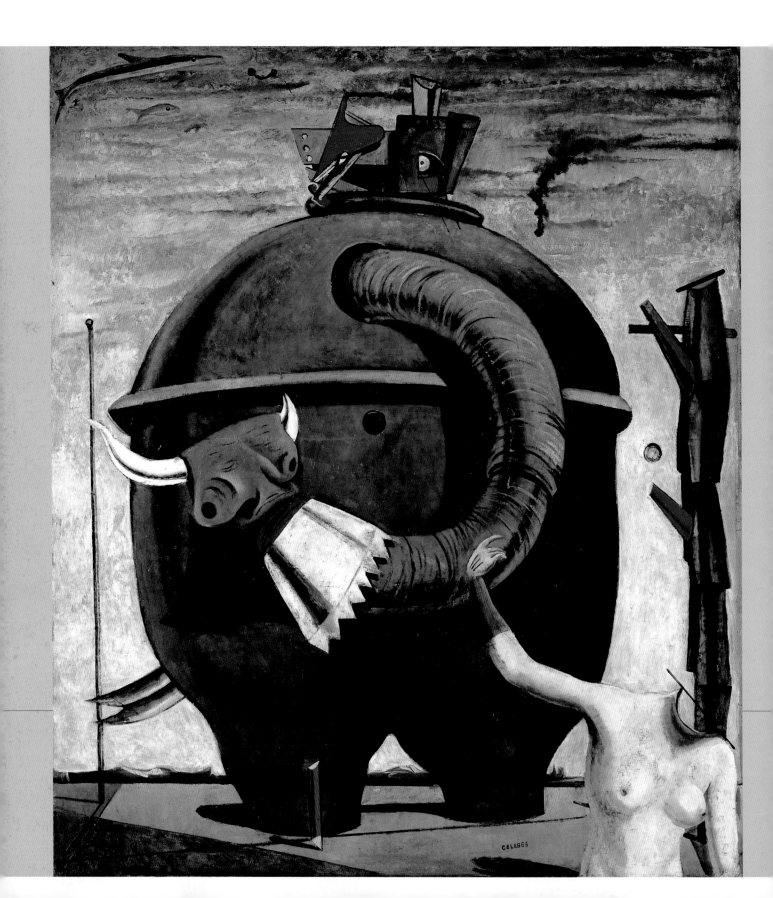

Max Ernst Paul Eluard

Devoured by feathers and submitted to the sea
He has left his shadow in the flight
Of the birds of liberty
He has left
The handrail to those who fall beneath the rain
He has left their roof to all who verify themselves.

His body was in order
The body of others has come to disperse
This ordinance that he had received
From the first stain of his blood on earth.

His eyes are in a wall
And his face is their heavy adornment
Another fiction of daylight
Another night, there are no more blind men.

Celebes, or *The Elephant Celebes* as it is sometimes known, was painted in Cologne in 1921 and was Max Ernst's first large picture. It was bought shortly after completion by Paul Eluard, who saw it on his visit to Cologne to meet Ernst that same year. From that moment onwards they established a firm friendship. Ernst's robust manner, obsessive fantasies and cynicism were complemented by Eluard's fragile temperament and idealistic dreams of love and social harmony. Eluard wrote fondly of Ernst throughout his life and dedicated two poems to him. The first was published in their collaborative volume *Répétitions*, and the second (reproduced here) was written for the catalogue of Ernst's exhibition at the Galerie Van Leer in Paris in 1926.

In this second poem Ernst is associated with the 'birds of liberty', which may signal his spirit of revolt as well as his alter ego, the bird Lop-Lop, which appears in many of his paintings. It may also refer to Ernst's physical appearance, which was described by many of his friends as 'bird-like'. The theme of birds, flight and freedom was important to both Ernst and Eluard, and was linked to the Surrealist faith in the importance of the imagination over the earthbound rational world. The poem also introduces the classic Surrealist opposition of day and night. Eluard's 'fiction of daylight' refers to the falseness of the daylight world which, according to the Surrealists, was less 'real' than the magical world of dream.

The themes of dream and night are also present in *Celebes*, which shows a strange dreamscape dominated by a large monster, half-elephant and half-machine. It has a long curling trunk that culminates in a horned head, shaped like a woman's chest, and two other tusks protrude from its left side, suggesting a second head or perhaps a tail. The painting exudes a threatening atmosphere that may be linked to Ernst's traumatic experience at the German frontline in the First World War. In the sky a trail of smoke suggests that a plane has been shot down and on top of the monster's body is a mechanical contraption with a single eye, emerging eerily like a periscope. Other holes, or eyes, are visible around the canvas, implying a preoccupation with sight and sight-lessness, which in the Surrealist view was related to the inner sight of the unconscious mind. The twilight setting also suggests

←
Max Ernst
Celebes 1921
Oil on canvas, 125.5 x 108
Tate, London

the transition between day and night, the waking world and dream, when ordinary objects begin to be transformed in the unconscious. In the foreground an enigmatic headless woman, or mannequin, beckons to the monster, as if calling him further into the world of fantasy.

The cut-out shapes and disjointed imagery clearly relate to Ernst's use of collage from 1919 onwards, but the translation of this technique into painting was inspired by the metaphysical landscapes of the Italian painter Giorgio de Chirico. Ernst began to imitate de Chirico's illogical juxtaposition of objects and his eerie, enigmatic settings. Unlike the laborious sifting and splicing of collage Ernst could now develop images freely as he worked. However, several sources have been discovered for this painting, which suggests that the process of collage was still foremost in Ernst's mind. The rotund shape of the monster has been taken from an illustration in an English anthropological journal of a huge communal corn-bin used by the Konkombwa tribe of the southern Sudan. A similar headless woman is also found in several of Ernst's collages of the period. The title is taken from a naughty children's rhyme about 'The Elephant of Celebes' which has 'sticky yellow bottom grease'.

The other important influence upon Ernst's paintings of this period was the writing of Sigmund Freud, whose works Ernst had studied before the war. Ernst avidly read Freud's descriptions of the dreams and fantasies of his patients and was familiar with his techniques of free association. These methods were of primary importance in Ernst's development of collage, which he saw as the material equivalent of free association and its counterpart, automatic writing. Collage became the key principle behind the development of Surrealism, and Ernst's famous description of the technique formed the basis for Surrealist activity: 'Collage technique is the systematic exploitation of the fortuitous or engineered encounter of two or more intrinsically incompatible realities on a surface which is manifestly inappropriate for the purpose – and the spark of poetry which leaps across the gap as these two realities are brought together.'

→
Max Ernst
Men Shall Know Nothing of This 1923
Oil on canvas, 80.3 x 63.8
Tate, London

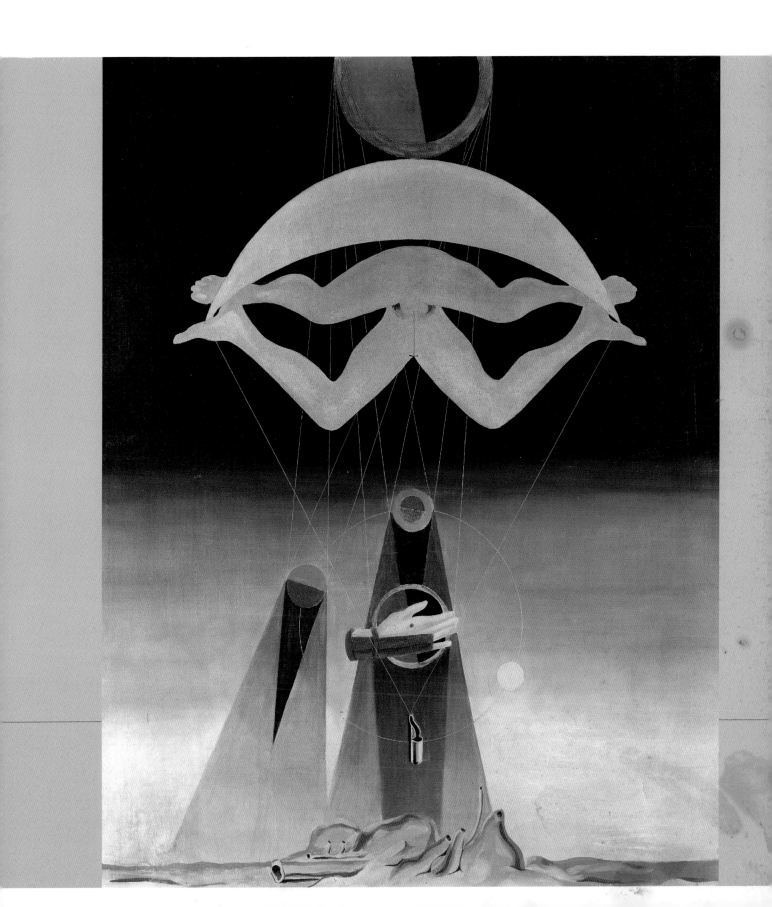

↗
Man Ray
André Breton (detail) c.1930

↗↗
Man Ray
Self-portrait (detail) 1932

André Breton & Man Ray
The marvellous and the everyday

André Breton was the pivotal figure of the Surrealist movement and one of the most important literary figures of the twentieth century. An intense and serious man, who could be dogmatic and overbearing, Breton also had immense charm and a magnetism that won him devoted admirers – and followers. His energy and determination was the driving force behind the movement, and his numerous essays and articles, as well as his poetry and novels, shaped the course of Surrealist ideas. In 1924 he launched the movement with his first manifesto, a now infamous document that lays out the key principles of Surrealism. In this, and in other tracts, Breton introduced the concept of 'the marvellous', which became a cornerstone of Surrealist theory. Although essentially indefinable, a classic and much-invoked example of 'the marvellous' is the celebrated phrase by Breton's hero, the Comte de Lautréamont: 'As beautiful as the chance encounter, on a dissecting table, of a sewing machine and an umbrella'.

Breton and Man Ray first met in Paris in 1921. Man Ray had just arrived from New York, where he had been involved in Dada activities with Marcel Duchamp and Francis Picabia. There Man Ray had become one of the leading exponents of Dada, flouting conventional aesthetics by making paintings with an airbrush, as well as producing collages, assemblages and even 'ready-mades'. He had started to experiment with photographic techniques, but also made photographic portraits to earn money. (Two of his earliest clients were the composer Edgar Varèse and the writer Djuna Barnes.) However, Man Ray wanted to be closer to the hub of Dada activity and set sail for France. On his arrival in Paris, he was immediately taken by Duchamp to meet the Dadaists at their regular café. Among them was André Breton, who 'already seemed to dominate the group, carrying his imposing head like a chip on the shoulder', as Man Ray recalled of their first meeting.

Man Ray was adopted by the group, despite his lack of French, and although he took up photography as his primary activity, he also continued to paint and to make Dada-inspired works. During this early period in Paris he made Gift (1921), an ordinary iron with a row of tacks stuck down the middle. With typical Dada defiance, the new configuration completely under-mines the object's utility, transforming it into a useless, but now

↑
Man Ray
Gift 1921
Photograph of original object by the artist, c.1921

↗
Man Ray
Delicious Fields 1922
Rayograph

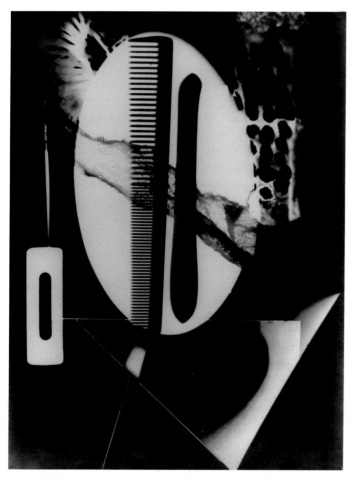

bizarre and (viciously) humorous object. This clash between the object's original function and its new anti-utilitarian form antici-pates the fascination for 'Surrealist objects' in the early 1930s and is a typical embodiment of Breton's concept of 'the marvellous'.

'Let us not mince words,' wrote Breton in the first *Manifesto of Surrealism*; 'the marvellous is always beautiful, anything marvellous is beautiful, in fact only the marvellous is beautiful.' Breton's idea of 'the marvellous' and its counterpart, 'convulsive beauty', are fundamental Surrealist concepts, yet they remain hard to pin down. For the Surrealists 'the marvellous' may be found in unexpected juxtapositions or turns of phrase, or it may be discovered in a chance encounter or strange coincidence. 'The marvellous' can be created, as in a poem or a Surrealist object, or it can simply be discovered in the street. The Surrealists frequently referred to the word '*dépaysement*', which translates approximately as 'displacement'. In this sense 'the marvellous' is often associated with transforming the familiar or everyday into something extra-ordinary or unexpected that challenges expectation and changes one's perception of the world. As Louis Aragon described it: 'The marvellous is that which opposes itself ... to what is so well known that it is no longer seen.'

Breton was quick to see photography as a ripe source of the marvellous. He believed that photography had a 'special power of suggestion' and praised its ability, through montage and overprinting, to bring together apparently distant realities into one image. While many people still saw photography as an essentially documentary medium, Breton recognised that it had innate 'Surrealist' qualities. He was so impressed that he included Man Ray among the few artists mentioned in the first manifesto.

The year before its publication Man Ray had chanced upon a technique for creating cameraless photographs, which he called 'rayographs'. The image was made by placing an object on light-sensitive paper and then exposing it to light. Once dev-eloped, a ghostly apparition of the object would appear on the paper. Breton was enchanted by this technique, which he saw as a visual parallel to automatic writing, since both involved a suspension of the rational mind and an openness to the workings of chance. In the rayographs the object is still identifiable, but it has been subject to strange distortions that make it appear closer to dream than to reality. Man Ray subsequently developed other photographic techniques such as 'solarisation', in which the colour tones of cast shadows are inverted, creating the impression of a halo or aureole of light around the object. Both these methods had the effect of disorientating reality and evoking the world of sleep. As Man Ray later wrote: 'It has never been my object to record my dreams – just the determination to realize them. To this end I never refer to them as dreams ... The streets are full of admirable craftsmen, but so few practical dreamers.'

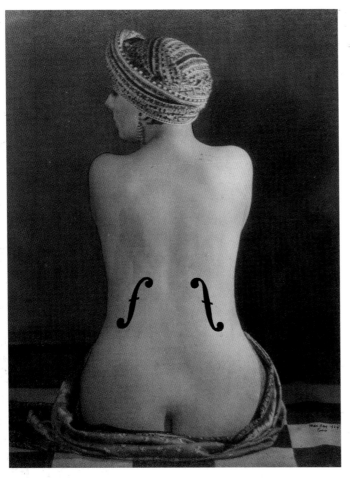

photographs rather than drawings.

However, as Surrealism gained momentum, so did Man Ray's career as a portrait photographer. He discovered that making portraits provided a good living, and soon all of Paris clamoured to be his subject. He photographed members of the French aristocracy as well as the avant-garde, including not only the Surrealist group but also expatriate writers, such as Ernest Hemingway, Gertrude Stein and James Joyce. But despite his success in this field, Man Ray is probably best known for his revolutionary photographs of the female body. For six years he lived with the celebrated singer and dancer Kiki of Montparnasse (née Alice Prin), who became his muse, the face behind many of his most iconic images including *Le Violon d'Ingres* (1924). Then, in the late 1920s, Man Ray lived and worked for three years with Lee Miller, a young American photographer who came to Paris to be his assistant (see page 51).

Among his best-known transformations of the female body is *The Primacy of Matter over Thought* (1929), in which, as a result of solarisation, the body is haloed and appears to float above the background. Through this technique Man Ray imbued his subjects with an other-worldly quality that is both lyrical and erotic. It corresponds to the Surrealist belief in the dizzying effects of desire, which were yet another potent source of 'the marvellous'.

Man Ray's career as a Surrealist was launched by the inclusion of seven of his photographs in the first issue of *La Révolution surréaliste* in 1924. From that point onwards he contributed regularly to the Surrealist reviews, with work ranging from 'straight' photographs for documentary purposes to rayographs and other manipulated photographic techniques. He also provided illustrations for many of the movement's publications: Breton used Man Ray's photographs to illustrate his classic Surrealist works *Nadja* (1928) and *L'Amour fou* (1937), and aspired to a time when all books would be illustrated with

↑
Man Ray
Le Violon d'Ingres 1924
Gelatin silver print, 28.2 x 22.5
Musée national d'art moderne,
Centre Georges Pompidou, Paris

↗
Man Ray
The Primacy of Matter over Thought 1929
Gelatin silver print, 20.8 x 29.1
Manfred Heiting, Amsterdam

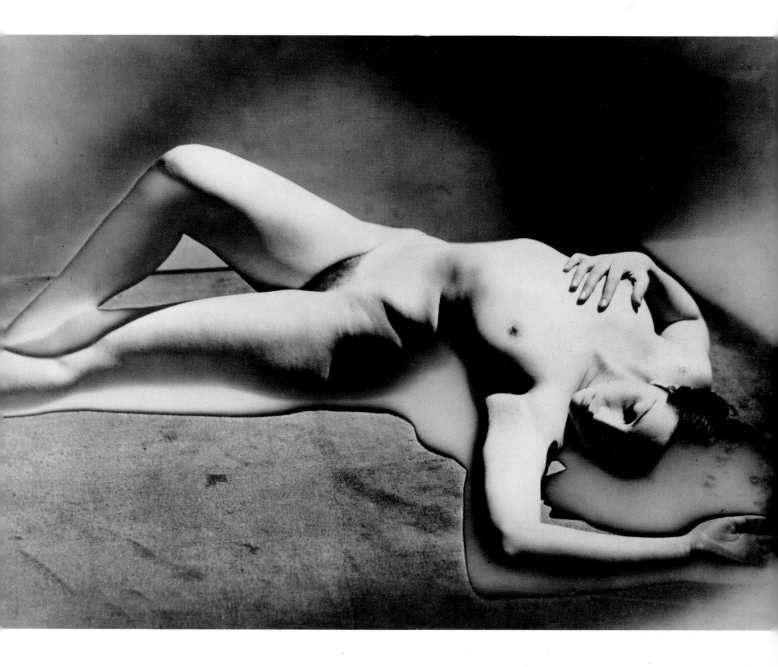

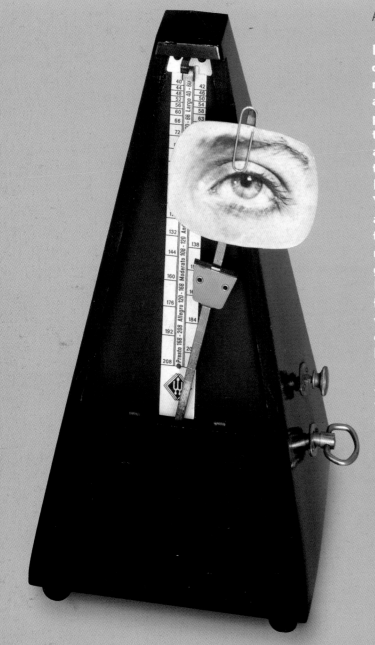

Automatic text from **Soluble Fish** André Breton

Less time than it takes to tell, fewer tears than it takes to die: I have counted everything, and there you are. I have made an inventory of the stones; they number as many as my fingers and a few more besides; I have distributed prospectuses to the plants, but all of them refused to accept them. I have played along with the music just for a second, and now I don't know what to think of suicide, for if I want to separate myself from myself the exit is on this side and, I spitefully add, the entry, the re-entry is on the other side. You see what else you still have to do. I don't keep reasonable track of the hours, of sorrow; I am alone, I am looking through the window; there isn't anybody going by, or rather nobody goes by (I underline goes by). Don't you know this gentleman? It's Monsieur Likewise. Allow me to introduce Madame Madame. And their children. Then I retrace my footsteps, my footsteps go back too, but I don't know exactly what they're going back on. I consult a timetable; the names of the cities have been replaced by the names of persons who have been rather closely related to me. Shall I go to A, shall I return to B, shall I change at X? Yes, naturally, I'll change at X. If only I don't miss the connection with boredom! Here we are: boredom, neat parallels, oh how neat parallels are beneath God's perpendicular!

Man Ray
Indestructible Object 1923, remade 1965
Wooden metronome and photograph,
height 22.2
Tate, London

Man Ray, like many avant-garde artists influenced by Dadaism, sought artistic expression in a variety of different forms and media. In New York he met Marcel Duchamp, the father of the ready-made, and under Duchamp's influence he began to incorporate everyday or found objects into his work. Although Duchamp was never officially a member of the Surrealist group, his belief in the mind's ability to transform a utilitarian object into a work of art was closely aligned with Surrealist thinking. According to Breton, the concept of 'the marvellous' could be understood as 'the unreality contained in reality itself'.

One of the most celebrated of Man Ray's early objects was the combination of a metronome with a cut-out photograph of an eye attached to its arm. As Man Ray later explained:

> I had a metronome in my place which I set going when I painted – like the pianist sets it going when he starts playing – its ticking noise regulated the frequency and number of my brushstrokes. The faster it went, the faster I painted; and if the metronome stopped then I knew I had painted too long, I was repeating myself, my painting was no good and I would destroy it. A painter needs an audience, so I also clipped a photo of an eye to the metronome's swinging arm to create the illusion of being watched as I painted. One day I did not accept the metronome's verdict, the silence was unbearable and since I had called it, with a certain premonition, *Object of Destruction*, I smashed it to pieces.

Although destined for destruction, Man Ray nevertheless remade the object in 1933, in response to exhibition requests, but this later version was lost during the Second World War. In 1958 he decided to remake the object once again, this time giving it the more appropriate title *Indestructible Object*. This particular version was remade in 1965.

This work is one of many examples of Man Ray's extraordinary ability to see beyond the utilitarian function of an object, and to transform it into something that challenges conventional perception. *Indestructible Object* draws out the human characteristics of the metronome: this squat figure with short legs is a despotic timekeeper with an ever-watchful cut-out eye. The eye that Man Ray affixed to the second version was that of his lover Lee Miller, with whom he had had a tempestuous relationship. In 1932 she finally left him and returned to America to pursue her own career as a photographer. When he remade the work during the following year, Man Ray attached the following bitter guidelines: 'Legend. Cut out the eye from a photograph of one who has been loved but is seen no more. Attach the eye to the pendulum of the metronome and regulate the weight to suit the tempo desired. Keep doing to the limit of endurance. With a hammer well-aimed, try to destroy the whole with a single blow.'

Man Ray's early assemblages and objects anticipate the craze for Surrealist objects at the end of the 1920s and demonstrate his natural eye for the marvellous in the everyday. A small alteration or addition to an existing object transforms it into something unexpected, strange and poetic. Breton admiringly described Man Ray as 'the great scrutiniser of everyday life's environment … the trapper indoors.'

↑
Man Ray
Le Merveilleux (The Marvellous) 1963
Mousetrap and wire cage, 12.5 x 30.6
Collection Vera and Arturo Schwarz, Milan

The Vertebral Sphinx André Breton

Patient and curved the lovely shadow walks round the paving
 stones
The Venetian windows open and close upon the square
Where beasts move freely fires trailing
Wet streetlamps rustle in a frame of swarming blue eyes
That cover the landscape upstream from the town
This morning prow of the sun how you steep yourself in the
 superb songs sighed in a traditional mode behind
 the curtains by the naked woman keeping watch
While the giant arum lilies turn about their waist
The bloody mannequin hopping on all three feet in the attic
He's coming they say arching their necks where the
 bounce of braids set free faintly pink glaciers
That split under the weight of a ray of light falling from the
 torn-off blinds
He's coming it's the glass-toothed wolf
Who eats up time in little round boxes
Who blows the overpungent fragrances of herbs
Who smokes little guide fires in the turnips at evening
The columns of the great apartments of marble and vetiver
 cry out
They cry caught in those to-and-fro motions which until
 then enlivened only certain colossal castings in
 factories
The motionless women on turntables will see
There is daylight on the left but night has completely fallen
 on the right
There are branches still full of birds that darken the gap
 in the casement window as they speed by
White birds laying black eggs
Where are those birds replaced now by stars edged with
 twin strands of pearls
A very very long fish head it is not yet he
From the fish head girls are born shaking a sieve
And from the sieve hearts made of Prince Rupert's drops
He's coming it's the glass-toothed wolf

Who was flying high above the vacant sites that reappeared
 above the houses
With sharp-leaved plants turned toward his eyes
Of such a green as to challenge a bottle of moss spilled upon
 the snow
His jade talons in which he gazes admiringly at himself while
 in flight
His fur the colour of sparks
It is he who growls in the forges at dusk and in deserted
 linen-rooms
Visible he can be touched moving forward with his
 balancing-pole over the swallow-lined wire
The watchful women lean out lean out of the windows
With their whole shadow side their whole side of light
The bobbin of day is tugged bit by bit toward the side of the
 Sand paradise
The treadles of night move ceaselessly

←
Man Ray
Return to Reason 1923
Gelatin silver print, 18.7 x 13.9
Art Institute of Chicago,
Collection Julien Levy

One of Man Ray's most haunting nudes, *Return to Reason* (1923), shows the naked body of his lover, Kiki of Montparnasse, a celebrated singer and personality of that bohemian quarter in Paris, where they lived together for six years. Standing next to a window, her body is transformed by the lines of shadow cast by the bars of the window frame and the patterns on the curtain. Her head is hidden in darkness and all that can be seen is an area of her torso where it catches the light. As the light streams through onto her body it refracts, creating haloes around her breasts and strange distortions along the contours of her torso. Man Ray turns the solid, fleshy form of Kiki's body into an insubstantial play of light and shadow. The image is dream-like or hallucinatory; it is recognisably a female body and yet it is imbued with an ethereal quality.

'There is daylight on the left but night has completely fallen on the right', wrote Breton in 'The Vertebral Sphinx', as if in memory of Man Ray's starkly contrasted nude. The poem was written in 1932 during Breton's intense love affair with the artist Jacqueline Lamba, the woman who inspired his novel *L'Amour fou* and whom he married in 1934. Like Man Ray's photograph, the poem builds an atmosphere of tension and excitement through the use of unexpected contrasts. In the poem 'pink glaciers' melt under the 'weight of a ray of light', and there are 'white birds laying black eggs'. The clash or combination of opposites, such as black and white, day and night, light and shade, clarity and obscurity, is a hallmark of Surrealist poetry, and is associated with the movement's ambition to unite rational and unconscious thought, dream and 'reality'.

Return to Reason was reproduced in the first Surrealist review, *La Révolution surréaliste*, where it was placed, without comment, among accounts of dreams. Shown alongside it was Man Ray's photograph of a doubled pair of breasts, the image repeated through the technique of double printing. Both photographs achieve a disorientation of the expected order of reality, seeming closer to the illogical world of sleep. Dreams, according to Freudian analysis, are a source of uninhibited desires, and the placing of these photographs among dream narratives implies that they can be seen as the fulfilment of erotic fantasy. In many of Man Ray's nudes the female body becomes the playground for male desire, subject to endless manipulations and contortions in an exploration of the vagaries of fantasy and desire.

In an article for Man Ray's book *Man Ray Photographies 1920–1934* (Man Ray Photographs 1920–1934) entitled 'The Faces of Woman', Breton writes that each of his photographs of women are 'a total of desires and dreams which have never before been had and which never will again'. He goes on:

> It needed the eye of a great hunter, the patience, the sense of the moment pathetically right when a balance, transient besides, occurred in the expression of a face, between dream and action. It needed nothing less than the admirable experience which, in the vastest plastic domain, is that of Man Ray, to dare, beyond the immediate likeness – which is often only that of a day or of certain days – to aim for the profound likeness which physically, morally engages the entire future. The portrait of a loved one should not be only an image at which one smiles but also an oracle one questions. In short, it needed all the sparkling curiosity, all the indomitable audacity which, besides, characterise the intellectual effort of Man Ray, in order that, out of so many contradictory and charming features which he chooses to give us, the one being composes itself in whom we are given to see the last incarnation of the Sphinx.

→
Man Ray
Lee Miller (Neck) c.1930
Gelatin silver print
Lee Miller Archives

Joan Miró & Michel Leiris
Peinture-Poésie: the poetics of the unconscious

Joan Miró's dream-like canvases of the 1920s are perhaps the most evocative works associated with the Surrealist movement. Often described as 'peinture-poésie', or 'painting-poetry', these works rely on the power of suggestion and symbolism rather than on explicit forms or meanings, bringing them closer to the elliptical style of written poetry.

Poetry was an important influence on Miró during the early 1920s, when he began to read the works of Surrealist heroes such as the Comte de Lautréamont, Arthur Rimbaud, Alfred Jarry and Saint-Pol-Roux. He shared the Surrealist interest in investigating language, and found that poetry offered the model for a new way of expressing himself and his relation to the external world. His stated aim was to create 'pictorial poems', and with this in mind he began not only to structure his paintings like poems but also to inscribe words or phrases onto the canvas. These canvases, which Miró called his 'tableaux-poèmes' or 'picture-poems', show a subtle interlacing of graphic signs, poetic allusions and visual images. The most intense period of his engagement with poetry was from 1924 to 1927, but he returned to use lettering in the mid-1930s, and poetry always remained an important source of inspiration.

Miró arrived in Paris in 1920, determined to make his name at the hub of the European avant-garde. Initially he was so overwhelmed that he was unable to paint at all, but slowly he developed a working rhythm that was to last for over a decade. Each year he spent the winter and spring in Paris, soaking up ideas and culture, and returned in the summer to the family farm in Montroig, Catalonia, where he worked in isolation, developing his ideas of the previous months. Miró was therefore present in Paris during the crucial years of experimentation that led to the establishment of Surrealism in 1924, as well as during Surrealism's heyday in the late 1920s.

Although Miró never became a signed-up member of either the Dada or the Surrealist group, he felt a close affiliation with their desire to overturn social and aesthetic convention. He shared their rejection of traditional painting governed by bourgeois standards of permanence and value, and wished to 'go beyond' painting or, as he later put it, 'to assassinate painting'.

In 1923 he met Robert Desnos, who then held pride of place as the champion 'sleeper' among the Littérature group during the 'époque de sommeils', or 'period of sleeping-fits'. Desnos amazed his audience by producing remarkable poetry in an allegedly unconscious state. It was probably through the influence of Desnos, as well as through the painter André Masson, that Miró first began experimenting with automatism in 1923–4. From that moment on his works began to develop a much looser syntax: the figurative canvases of the early 1920s were transformed into paintings in which rudimentary signs and marks floated on flat planes of colour. 'I have already managed to break absolutely free of nature', wrote Miró in 1923, 'and the landscapes have nothing whatever to do with outer reality. Nevertheless they are more Montroig than if they had been painted from nature.'

Although few of these paintings were exhibited at the time, Miró began to develop a private reputation among the Surrealists. Nevertheless, he did not meet André Breton until 1925, and claimed that Breton had 'ignored my existence until my painting freed itself in the direction of poetry and dreams'. At Miró's exhibition at Galerie Pierre in 1925 Breton bought two paintings, including Miró's radical new work The Hunter (Catalan Landscape) (1923–4). The painting can be deciphered as a Catalan peasant barbecuing a sardine on a grill in the countryside, but Miró has pared this scene down to a few essential symbols and marks. Thin vertical and horizontal lines depict the body of the peasant, who smokes a pipe and wears the traditional Catalan barretina hat. An egg-shaped sun with black curvy rays floats at the top of the canvas and in the foreground is a huge sardine with a triangular tail, emphasised by the written letters 'SARD'.

Inspired by Surrealist experiments in automatism, Miró developed a personal vocabulary of marks and symbols in which different levels of meaning operate at the same time. This also shows Miró's digestion of Cubism, a movement that, ten years earlier, had demonstrated the flexibility of the visual sign – in the same way that a Cubist guitar could be seen as a bottle or a female body, so Miró's sun could also be read as a spider or as female genitalia. For Miró these different layers of meaning enriched the image and brought it closer to the condition of poetry.

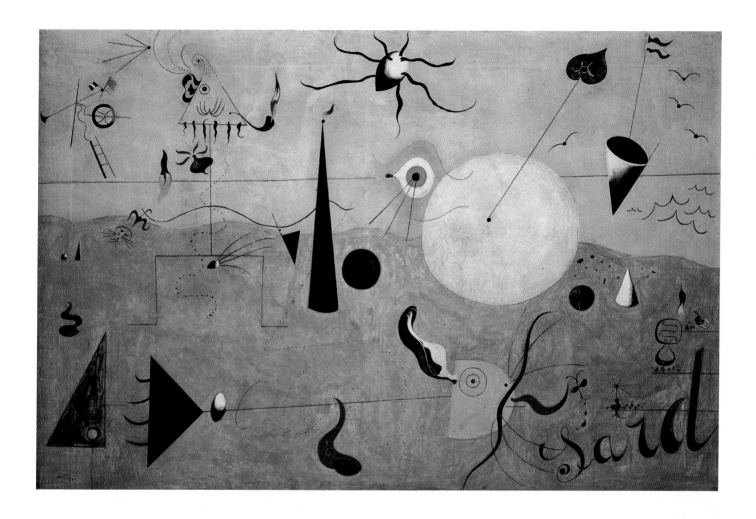

↑
Joan Miró
The Hunter (Catalan Landscape) 1923–4
Oil on canvas, 64.8 x 100.3
The Museum of Modern Art, New York

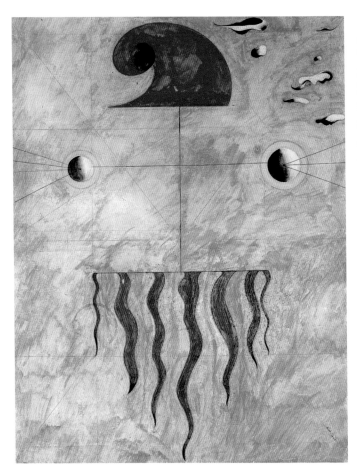

Miró's interest in the flexibility of visual images was also influenced by investigations into the flexibility of language. This topic particularly interested Miró's friend, the poet and writer Michel Leiris. Although Leiris joined the Surrealist ranks in 1924, like Miró he always remained aloof from the core group. His contribution to the movement centred on experiments with language, such as his 'Glossary', which was published in *La Révolution surréaliste* in instalments between 1925 and 1926. In this text Leiris challenged the idea that words can be understood through etymology or dictionary definitions, and argued that, through metaphor, rhyme and analogy, words contain many different connotations and meanings: 'By dissecting words ... we discover their most hidden virtues and the secret associated sounds, shapes, and ideas. Then language changes into an oracle and we have here a thread (however tenuous it be) to guide us inside the Babel of our mind.' Miró's works of the mid-1920s show his attempt to translate the fluidity of language, the meandering patterns of thought, into visual imagery. His vocabulary of signs and marks are strung together on the canvas like the disparate ideas and images produced by free association or automatic writing.

Miró was first introduced to Michel Leiris in 1922 at the rue Blomet studios, near Montparnasse, which Miró shared with André Masson and a number of other artists. These studios became the meeting place for a group of artists and writers who were interested in Surrealist ideas, but wished to remain detached from Breton's all-powerful stronghold. Miró and Masson had adjacent studios, and while Miró's was scrupulously neat and tidy, Masson's was disorderly and chaotic, the site of many evenings of drink and discussion. 'More than anything else the rue Blomet was friendship,' Miró later recalled, 'an exalted exchange and discovery of ideas amongst a marvellous group of friends. Among those who came to the gatherings at Masson's studio were Michel Leiris, who has remained my closest friend, and Roland Tual, Georges Limbour, and Armand Salacrou. We talked, we drank a lot. Those were the days of brandy and water, of curaçao tangerines.'

The artists and writers who gathered at the rue Blomet were to form the nucleus of the 'dissident' Surrealist group, which broke away from Breton in 1929 and regrouped around the writer

↑
Joan Miró
The Head of a Catalan Peasant 1925
Oil on canvas, 92.4 x 73
Tate, London and Scottish National Gallery
of Modern Art, Edinburgh

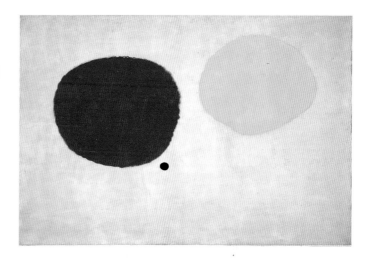

Georges Bataille. Leiris was among the defectors and in the same year he co-founded, with Bataille, a rival Surrealist magazine called *Documents*. This magazine brought a strong ethnographic and sociological flavour to Surrealism, and included contributions from well-known ethnographers as well as articles such as 'Primitive Art' and 'André Masson – An Ethnographic Study'. These studies drew parallels between children's art, the art of prehistoric peoples and the automatist works of Surrealist artists. One issue even juxtaposed images of Miró's paintings with drawings by a six-year-old. Both Miró and Masson began to be viewed as artists who exemplified an untutored innocence, where imagery springs directly from the unconscious.

In the mid-1920s Miró returned briefly to a more concrete style of painting, choosing to work again with figurative subjects. In contrast to the loosely sketched forms of his 'dream paintings', he introduced defined shapes filled with flat colour and the forms were anchored, rather than floating, on the picture plane. Towards the end of the decade, however, in 1928, Miró suffered a period of creative doubt and stopped painting altogether. During his 'crisis of painting' between 1929 and 1930 he concentrated on collage, which had a dramatic effect on his subsequent work: when he began to paint again, he created sparse and empty canvases that verged on complete abstraction.

In 1930 Leiris contributed a study of this later work to *Documents*, in which, using deliberately poetic language, he associates Miró's painting with a mystical asceticism, subject to the processes of chance and magic. He writes that Miró's canvases are inscribed with 'mysterious poems, long marks in obscure configurations, uncertain like the sand carried by rivers in a perpetually changing current, subject to the movement of wind and rain.' Other critics described Miró's paintings as a kind of sorcery, and Miró even perpetuated this myth himself by statements such as: 'It is difficult for me to talk about my painting, as it always arises in a state of hallucination.' The idea of the artist or writer as a medium, or channel, for the unconscious was one of the founding principles of Surrealism, and led Breton to characterise Miró as 'perhaps the most Surrealist of us all'.

↑
Joan Miró
Painting (Untitled) 1930
Oil on canvas, 150.5 x 225
The Menil Collection, Houston

↑
Joan Miró
Photo – This is the Colour of my Dreams
1925
Oil on canvas, 96.5 x 130.2
Private collection

Extract from **The Country of my Dreams** Michel Leiris

My hands resting on a steel blade, I stand on the steps lead-
ing to the vistas of the void. Through my body runs a bundle
of invisible lines connecting each of the intersecting points
of the edges of the edifice with the centre of the sun. I stroll,
unhurt, among these threads piercing through me, and each
spot of space blows a new soul into me. For my spirit does
not follow my body in its revolutions; like a machine drawing
its energy from the line stretched along its route, my flesh
comes to life from the contact of the lines of perspective that,
on their way, irrigate its most secret cells with the air of the
monument, fixed soul of the structure, reflections of the
curve of the vaults, of the arrangements of the fountains,
and of the walls that meet at right angles.

If I draw a circle around me with the point of my sword, the
threads that feed me will be severed, and I won't be able to
come out of the circular dungeon, having separated myself
forever from my spatial food and being confined in a small
column of immoveable spirit, narrower than the cisterns of
the palace.

Stone and steel are the two poles of my captivity, the
communicating vessels of slavery. I cannot escape the one
without shutting myself into the other, till the day comes
when my blade will pull down the walls with huge blows
of sparks.

In a detailed letter about his work, sent to Leiris in the summer of 1924, Miró wrote: 'My latest canvases are conceived like a bolt from the blue', adding, 'There is no doubt that the canvases that are simply drawn with a few dots of colour, a rainbow, are more profoundly moving. These move us in the elevated sense of the word, like the tears of a child in the cradle. The others are like the screams of a whore in love.' During that year Miró had been experimenting with automatism, a technique that he had been introduced to the year before. Together with other artists associated with Surrealism, he was preoccupied with the question of how automatism could be translated into visual imagery. With his friend and neighbour André Masson, Miró tried to induce trance-like states in which he could create spontaneous works, direct from the unconscious. He was also inspired by the effects of extreme hunger, recalling: 'I ate little and very badly ... hunger gave me hallucinations and the hallucinations gave me ideas for paintings.'

Miró later explained that: 'Rather than setting out to paint something, I begin painting. As I paint the picture begins to assert itself under my brush. The form becomes a sign for a woman or a bird as I work ... the first stage is free, unconscious.' And yet, despite Miró's desire to perpetuate the myth of his spontaneous practice, there is much evidence to show that he planned his paintings rigorously, including the apparently free-form paintings of the mid-1920s. Although *Photo – This is the Colour of my Dreams* (1925) appears to be a very simple and spontaneous composition, it was in fact based on a previous, possibly automatic, drawing. There are only two small variants in the drawing: the first is an additional dark area of colour inside the patch of blue, and the second is that the 'h' of 'Photo' is smaller than the rest of the lettering, as if it had been forgotten or the intention was to make the word unstable. Many of Miró's spare canvases of this period have blue cavernous washes for the background or predominant colour, but this painting uses only a patch of blue. As the text beneath it indicates, Miró associated the colour blue with dreams, and since blue is the colour of the sea and sky, it is naturally linked with infinite and unfathomable space. Here the background is washed with white, although this is delineated by visible vertical lines produced by the impression of the wooden stretcher bars on the back of the canvas. Miró uses these vertical lines to create a flat plane, which he then punctures with the patch of blue. Like a parting of the clouds, the area of blue acts like a window, leading the eye into the deeper space of the painting, and by implication into another world.

In this extract from the automatic text 'The Country of my Dreams' Leiris also evokes an image of the void. He imagines the world of dream to be a place where there are no boundaries between body, spirit and the external world. The protagonist of his narrative is presented as a super-being who fantasises about destroying his prison of 'stone and steel ... with huge blows of sparks'. Leiris's imagery reflects the Surrealist desire to go beyond the limits of the material, earthbound world towards the infinite, or the 'vistas of the void'.

Some commentators have interpreted the word 'Photo' in Miró's work as an allusion to painting's traditional role as a reflection or reproduction of the external world. Miró's response is both aggressive and enigmatic: instead of a photographic reproduction of the world, he presents a radically emptied out canvas with a simple blue smudge. The true reality, he implies, is not the external world, but the world of dream and the imagination.

↑
Joan Miró
Painting 1927
Tempera and oil on canvas, 97.2 x 130.2
Tate, London

Joan Miró Michel Leiris

A finger, an eyelash, a sexual organ shaped like a spider, a sinuous line or the echo of a glance, the flax of thought, the warm savannas of a damp-contoured mouth, animals or vegetables at nurse, composite monsters with newspapers for limbs, trees which bear eyes, crevices in the stone where insects swarm, bark eaten with mildew in an infinite variety of patterns and colours, numbers and letters from a copy-book, persons reduced to a moustache, the sharp point of a breast, a pipe's glow or perhaps the ashes of a cigar: in this country of surprising candour the horns of the moon are a snail's horns and extravagant tubercles sprout in the meteoric sky.

The creator of this country has gathered, in the obscure byways of Reality, the few particles toward which his instincts drive him as if to the feet of idols. Often a straight line represents a human being, for in this being he loved only the straight line; in the same way the bird is represented by a feather, the swift arrow of his flight or mark of his talons. Sometimes of mankind there remains only the mark of a foot on the wet sand; the sea mingles its waves with the undulations of a bathing girl; and the spermatic fusion of the sexes is translated only by a thread.

A man like Miró belongs to that sorcerer race whose feats seem often ridiculous because of their bizarre tone and their air of coming from somewhere else. A cauliflower or perhaps the rising sun. His lines are only indications, not a diagram, but rather the marks by which phenomena can be recognised. In his canvases, built like the delicate and lacy architecture of certain insects, Nellie was a lady, will-o'-the-wisp, a woman's hair, the windows open on a night peopled with miracles, while reason is still untangling its threads, in spirals more tenuous than the smoke of a devotional candle, burned and snuffed out before a pyramid.

↑
Joan Miró
The Body of my Brunette... 1925
Oil on canvas, 129.8 x 95.8
Private collection

Miró was an avid reader during his early years in Paris, and poetry had a decisive influence upon his painting. He imitated the compactness of verse and reduced his formal repertoire to a series of schematic signs, marks and symbols that were often placed lyrically across cavernous, monochrome backgrounds. Miró always insisted that these are were not abstract marks, but a personal vocabulary of forms which, like poetic images, have multiple symbolism: 'For me, the sex of a woman, it's like the planets, or shooting stars; it's an element of my vocabulary.' The idiosyncrasy of Miró's imagery is echoed beautifully in Leiris's lyrical text about the painter which is quoted here. More like a prose poem than a piece of art criticism, Leiris's fluid and colourful language carefully evokes the patterns of Miró's imagery.

In 1924 Miró began to integrate words or phrases into his paintings, in the series of works he called *tableaux-poèmes*. Sometimes the words and phrases refer to personal experiences, while at other times Miró used quotations from familiar poems or popular songs, but many of the words are disparate and nonsensical, evocative rather than explicit. This mixing of verbal and pictorial imagery may derive from his notebooks, where ideas for paintings were jotted haphazardly alongside sketches, or may have been inspired by the literary tradition of the *calligramme*, a type of poetry in which the shape of the letters on the page imitates the subject of the poem. However, he generally avoided exact replication of an image and an idea, preferring to use words or phrases that enrich and amplify the visual rather than pin it down.

The Body of my Brunette... (1925) is one of the most verbally dense of Miró's *tableaux-poèmes*, and has sparked considerable debate about possible literary sources. The words appear to have been placed last on the canvas, superimposed on a schematised female form in which two blue breasts sit along the horizontal axis of her white cruciform body. As Leiris points out in his text: 'Often a straight line represents a human being, for in this being he loved only the straight line.' The white 'head' of the woman bends over to meet a similarly fluid white shape, and they are both tipped in sensuous red, suggesting the lips of lovers meeting in a kiss. This reading is strengthened by an interpretation of the painting that links it to a poem called 'The Two Snakes that Drank too much Milk' by Saint-Pol-Roux, a poet whom Miró much admired. In the poem, a lover in a darkened room has a nightmare in which two unidentifiable white forms appear before him. It goes on to list possible interpretations of the two forms as two moonbeams, two tears of snow, two branches of hawthorn, two swans' necks and two snakes having drunk too much milk. Although Miró may not be illustrating the poem consciously, the proximity of the forms in the painting to the subject of the poem is too close to be mere coincidence. Furthermore, Saint–Pol-Roux's poem is almost a manifesto for poetic freedom and the imagination, demonstrating that an imaginary image cannot be fixed in a single word.

The words in this painting can be translated as 'the body of my brunette / that I love / like my pussycat / dressed in green salad / like hail / it's all the same'. These have been linked to a poem by another of Miró's favourite authors, Guillaume Apollinaire. In 'Rotting Enchanter' a man describes his lover as 'a pussycat' and then compares her to an April garden full of fresh 'greens'. This imagery links closely to the phrases in Miró's canvas, although they seem half-remembered or perhaps deliberately obscured. 'I make no distinction between painting and poetry,' Miró later said, 'Painting and poetry are made in the same way as you make love: with an intermingling of blood, a total embrace, without any holding back, without any kind of self-protection.'

↑
Joan Miró
A Star Caresses the Breast of a Negress
(Painting Poem) 1938
Oil on canvas, 129.5 x 194.3
Tate, London

↗
Man Ray
Louis Aragon (detail) c.1925

↗↗
Man Ray
Alberto Giacometti (detail) 1932

Louis Aragon & Alberto Giacometti

Woman: symbol of revolution

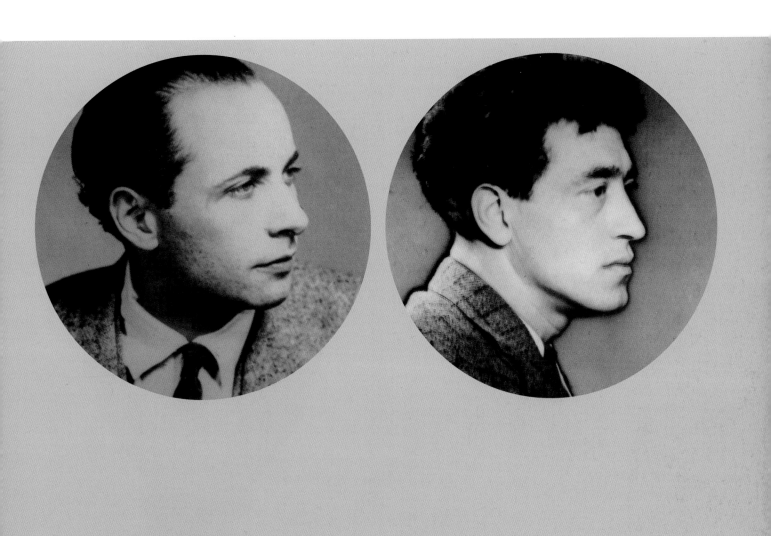

Louis Aragon & Alberto Giacometti

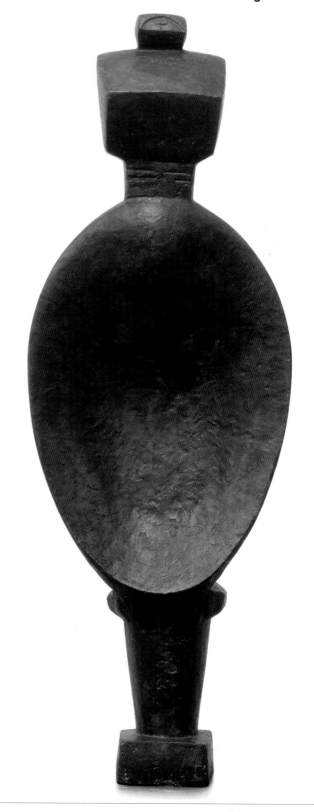

'The problem of woman', wrote André Breton in the *Second Manifesto of Surrealism* (1929), 'is the most wonderful and disturbing problem there is in the world'. Women played a vital role in the Surrealist imagination. They are the instruments, and objects, of love and desire and, as muses, they inspire the (predominantly male) Surrealists' hungry imaginations. Historically the rational was seen as a male domain. In the nineteenth century the French neurologist Jean-Martin Charcot (1825–1893) studied the behaviour of hysterics at a female asylum outside Paris, and claimed that hysteria was the result of women's weak neurological system. Women, therefore, were considered to be less in control of their reasoning faculties than men, and more prone to emotional or hysterical states.

 Although this was traditionally viewed as a negative attribute, for the Surrealists it was something to be celebrated. They even published Charcot's photographs of female hysterics in their reviews. Women, they believed, were more in touch with their unconscious and closer to the sought-after domain of the irrational. 'The time has come', Breton wrote, 'to assert the ideas of woman at the expense of those of man, the bankruptcy of which is so tumultuously complete. Specifically it rests with artists … to ensure the supreme victory of all which derives from a feminine system in the world in opposition to a masculine system.' In their desire to challenge the conventions of society and the emphasis placed on the rational, the Surrealists championed 'woman' as a symbol of their revolution.

 Giacometti moved to Paris from Switzerland in 1922 and probably heard about the Surrealist group, and began to read its reviews, soon afterwards. It was not until 1929, however, when he met the painter André Masson, that he was introduced to other members of the group and to those known as the 'dissident Surrealists'. Giacometti shared the dissident Surrealists' interest in ethnography and shortly after his arrival in Paris his Cubist-inspired works gave way to the influence of African and Oceanic sculpture, which he admired in the Musée de l'homme. So-called 'tribal' or 'primitive' art and culture was then at the height of fashion and an important source of artistic inspiration among the avant-garde. Like women, this art was seen as a source of

↑
Alberto Giacometti
Spoon Woman 1926–7, cast 1954
Bronze, 146.1 x 51.4 x 25.4
Solomon R. Guggenheim Museum,
New York

↗
Germaine Berton surrounded by portraits
of the Surrealists and others (including
Sigmund Freud, lower right, next to
Germaine Berton)
La Révolution surréaliste no. 1, December 1924

the exotic and irrational.

During this period the theme of sexuality began to creep noticeably into Giacometti's work. *Man and Woman* (1928–9; see page 71) demonstrates a combination of radically simplified forms derived from African and Oceanic sculpture as well as a new interest in eroticism. The concave spoon shape, which he employed to signify the female body, can be seen as a potent erotic symbol suggestive of female genitalia or the female body as a receptacle. This gendered symbolism is made more explicit by the phallic point that pierces the receptive and bowing spoon. Besides its eroticism, the sculpture has clear connotations of violence, another key theme that arises in Giacometti's work at this time.

The potent mix of sex and violence in these works has been attributed to the break-up of Giacometti's relationship with an American sculptor called Flora Mayo, but it must also be linked to his knowledge of Surrealist activity. The very first issue of *La Révolution surréaliste*, in 1924, includes an image of the anarchist Germaine Berton, surrounded by photo-portraits of members of the Surrealist group and mentors such as Sigmund Freud. Berton was infamous for having assassinated a right-wing politician, an act celebrated by the Surrealists as an example of the wonderfully subversive force of woman. Although the Surrealists' sympathy with left-wing political causes meant that they frequently advocated acts of aggression towards the right-wing establishment, the criminal acts performed by women were of particular interest. Later issues of Surrealist magazines featured other female criminals, such as the notorious murderers, the Papin sisters, and in 1933 the Surrealists published a book dedicated to Violette Nozières, a woman convicted of murdering her incestuous father. As these examples indicate, the Surrealists saw women as a powerful subversive force whose sexuality was often linked to violent and transgressive acts. To the poet Louis Aragon, one of the most politically active of the Surrealist group and later a committed Communist, Berton was the ideal Surrealist heroine. In the first issue of *La Révolution surréaliste* he described her as 'that perfectly admirable woman who represents the greatest defiance against slavery, the most beautiful protest before world opinion against the hideous lie of happiness'.

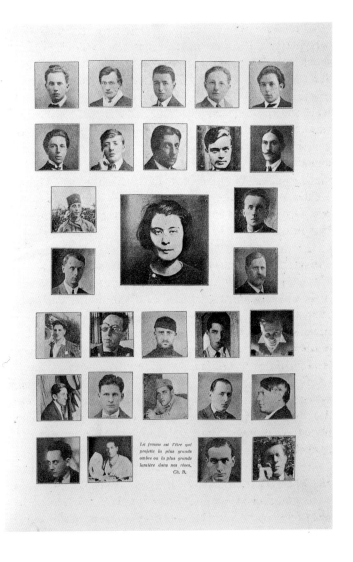

Louis Aragon, one of the founder members of the Surrealist group, was a poet known for his verbal dexterity and his charm. André Breton later wrote that 'his mental agility was unparalleled', while Philippe Soupault remembered 'Aragon the stunning, tireless "talker", detecting something unusual on every street corner. He always made grand gestures and couldn't help looking at himself in every window and mirror.' Aragon published a number of important volumes of poetry, but his most significant contributions to Surrealism were his novel Le Paysan de Paris (The Paris Peasant) (1926), the selection of writings entitled Le Libertinage (The Libertine) (1926), the social critique 'Treatise on Style' (1928), and his important theoretical tract 'In Defiance of Painting' (1930). Aragon's most famous work, Le Paysan de Paris, is a description of his aimless wanderings through Paris, seeking out 'the marvellous' in abandoned or obscure parts of the city. 'No one else', Breton wrote, 'could have been carried away by such intoxicating reveries about a sort of secret life of the city'. In Le Libertinage, a collection of many of Aragon's earliest Surrealist writings, he explores his concept of libertinism, a counterpart to the Surrealist belief in the free expression of desires.

Aragon joined the French Communist Party in 1927, and from that point onwards his writing became increasingly devoted to the service of Communism. His relationship with the revolutionary Russian writer Elsa Triolet, and his first-hand experience of the rise of the Nazi party in Germany, had convinced him that the Stalinist struggle was the only path to revolution. Aragon's final break with Breton and the Surrealist group was caused by the publication of his rallying Communist poem, 'Red Front', which resulted in his prosecution. The ensuing scandal and the debates that surrounded it became known as the 'Aragon Affair' and culminated in his departure in 1932. When Aragon left the group, Giacometti followed, later saying 'it was Aragon's position that most appealed to me'. Although Giacometti was not a member of the Communist party, for a long time he shared Aragon's active political commitment and they worked together on collaborative projects until after the Second World War. Like many of the Surrealists, however, Giacometti hovered between political commitment and artistic autonomy, and later renounced political activity altogether.

Aragon pursued the principle of revolt as both a political and a poetical concept. In both cases it was an essential means to create a new reality or, as Aragon described it, 'a mythology of the modern'. In his writings he promoted the idea of 'scandal for scandal's sake', placing greater value on the subversive or transgressive act than on the purpose behind it. By singling out Germaine Berton's 'defiance', Aragon demonstrated that the criminal act was not in itself enough – it is the fact that it was performed by a woman that made it a truly Surrealist act. These elements of subversion and transgression were essential to the Surrealist goal of freedom.

→
Albert Giacometti
Man and Woman 1928–9
Bronze, 40 x 40 x 16.5
Musée national d'art moderne, Centre
Georges Pompidou, Paris

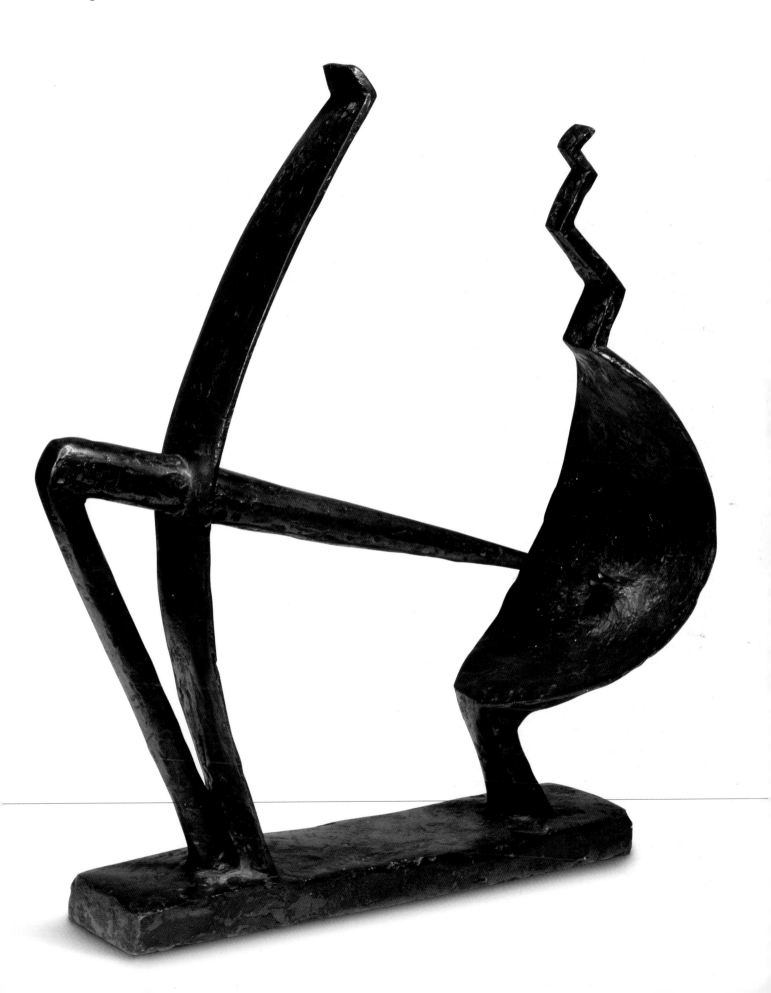

↑
Alberto Giacometti
Reclining Woman Who Dreams 1929
Painted bronze, 23.5 x 42.8 x 14.6
Hirshhorn Museum and Sculpture Garden,
Smithsonian Institution.
Gift of Joseph H. Hirshhorn, 1966

Extract from **A Feeling for Nature at the Buttes-Chaumont**
Louis Aragon

And yet, woman, you take the place of all form. I had scarcely begun to forget this neglect, even the black indifference that you cherish, before you are here again, and everything dies in your footsteps. In your footsteps on the sky a shadow enfolds me. In your footsteps toward the night I recklessly erase my memory of the day. Charming superstitious child, you are the epitome of a marvellous world, of the natural world, and it is you who are reborn when I close my eyes. You are the wall and the breach. You are the horizon and the presence. The ladder and the iron bars. The total eclipse. The light. The miracle: and how can you think of anything that is not a miracle when the miracle is there in its nocturnal robe? So for me the universe gradually fades away, melts, while from its depths there rises up an adorable phantom, there ascends a woman larger than life whose outline is at last clear, who, with nothing separating her from me, appears everywhere in the most positive guise of an expiring world. O desire, twilight of forms, in the rays of this occident of life, like a prisoner I grip the bars of liberty, I, the jailbird of love, a convict number … followed by a figure too high for my mouth to contain. The woman larger than life is still growing larger.

This sensuous and erotic sculpture brings together a variety of key Surrealist themes. It was made in the same year that André Breton invited Giacometti to join the Surrealist group, although it also demonstrates that Giacometti had been absorbing Surrealist ideas for some time.

In this sculpture Giacometti reinterprets the traditional subject of the reclining female nude through the Surrealist lens. The work betrays his early interest in Cubism but goes a stage further, verging on the completely abstract. The overall structure evokes a bedstead, but the space in between the two layers forms the classic curvaceous shape of a woman's body. This is an example of Giacometti's 'openwork' sculpture, in which he uses gaps or blank spaces as integral sculptural elements. The spoon shape, which Giacometti had begun to employ as a symbol for the female body around 1926, is used here to signify the woman's head. These elements combine to form a soft and sensual image of a woman sleeping, as the French title indicates: *Femme couchée qui rêve*. '*Couchée*' translates as 'sleeping' or 'in bed' rather than simply 'reclining'.

The most animating parts of the composition, however, are the three bars that pierce the woman's torso like parallel bolts of lightening. The penetration of a curvilinear female form by hard straight bars has obvious sexual implications, turning the work from an image of passive repose into a sexually charged love scene. The two wavy layers that make up the woman's body now double as the undulations of a couple making love. Yet a sense of violence and aggression is also implicit in the scene; the penetrating bars may also be instruments of attack.

The sculpture effectively combines several aspects of the Surrealists' myth about 'woman'. The implication of sexual activity, whether it is real or dreamed, casts the woman in an erotic role as a symbol of (male) desire. But equally potent in the Surrealist imagination is the fact that she is dreaming. The Surrealists believed that dreams were a direct source of unconscious imagery. The flow of irrational images during sleep is unmediated by rational constraint, and for the Surrealists this represented a powerful alternative to the 'reality' of waking life. As symbols of the 'revolution of the mind', women were closely

associated with the dream world. In Aragon's eulogy to woman-
kind in 'A Feeling for Nature at the Buttes-Chaumont', he
describes woman as 'the epitome of a marvellous world' who
is 'reborn when I close my eyes'. Aragon repeatedly links woman,
and his desire for her, to the nocturnal world through metaphors
such as 'twilight of forms' or the 'rays of this occident of life'.
By submitting to 'woman' and her dream world, 'the universe
gradually fades away' and Aragon may 'recklessly erase my
memory of the day'. In contrast to the rationalist, patriarchal
world of day, Aragon and Giacometti look to women as the
subversive force of the night.

↑
Alberto Giacometti
The Cage 1930–1
Wood, 49 x 26.5 x 26.5
Moderna Museet, Stockholm

Woman with her Throat Cut (see pages 76–7) is without doubt one of the most terrifying and extraordinary images of the twentieth century. It depicts a woman, with legs splayed and arms outstretched, who, it is implied, has been raped and brutalised. Her neck is distended into an extension of her spine, and has a sharp cut in it, evoking her mortal wound as well as a mouth gaped in pain and distress. The woman's back arches in apparent agony, encased within a jagged shell that may indicate a ripped-open rib cage or simply the tears in her flesh. Her two hands are deformed and useless; one has been flattened into a spoon-shape and the other ends in a phallic lozenge that dangles on a hook. Giacometti said that this referred to the nightmare of not being able to move one's hand, a further indication of this woman's utter helplessness.

Yet what adds an extraordinary edge to this sculpture is that, while vulnerable and mutilated, the woman is herself frightening. The jagged shapes of her back have been compared to the jaws of the 'mantrap' plant, threatening to snap shut if touched, and her insect-like frame and legs have been identified with the praying mantis, an insect notorious for the female's ability to devour the male after, or even during, copulation. The praying mantis fascinated the Surrealists, who championed it as another indication of woman's revolutionary potential.

Giacometti's terrifying sculpture can also be linked to traditional influences. Many artists have painted images of 'the vanquished woman' for the titillation of their male audiences. Although a large number of these have Biblical or mythological sources, such as the stories of Judith, Leda or Lucrece, they frequently employ blushing females in a state of semi-nudity and have deliberately erotic overtones. Giacometti's interest in the theme of sex and violence had a different origin, however. Despite joining the 'orthodox' Surrealist group in 1929, Giacometti also associated with the group known as the 'dissident Surrealists', centred around Georges Bataille.

Like Breton and the orthodox Surrealist camp, Bataille was enormously influenced by the Marquis de Sade, and also promoted eroticism and the liberation of latent desires. It was Bataille's enthusiasm for perversity and cruelty in the

pursuit of these desires, however, that revealed the difference between their two philosophies. In the extract from 'The Passage de l'Opera' (see page 76), danger and delinquency are inspired by love. For Aragon and the 'orthodox Surrealists', transgression and taboo-smashing were pursued in the cause of love and revolution, underpinned by idealism and a sense of purpose.

Giacometti never altogether relinquished this sense of idealism, and later went on to collaborate with Aragon on political projects. However his work in the early 1930s relates closely to the ideas of Bataille and the 'dissident' camp, and demonstrates his interest in the ethnographic studies published in the group's review, *Documents*. In a study of the Aztec ritual of human sacrifice Bataille developed a theory about the interrelationship of destruction and creativity, and later claimed that the sexual act is equivalent to the criminal act. It was in this context that Giacometti began to work on sculptures with blatantly violent and sadistic themes.

In the year following *Woman with her Throat Cut* Giacometti published a disturbing essay in the orthodox Surrealist journal *Le Surréalisme au service de la révolution* entitled 'Yesterday, quicksands'. In this he recounts a childhood fantasy of rape and murder: 'I could not go to sleep at night unless I imagined that I had gone through a thick forest, at nightfall, and that I had reached a great castle rising in a most secluded and unknown place'. He then imagines killing 'two defenceless men' and raping two women whose 'cries and moans echoed through the whole forest'.

In this chilling fantasy Giacometti dares to explore the fundamental taboos of rape and murder which act as metaphors for the Surrealist desire to undermine all traditional values and release unconscious desires, however frightening. In their love and desire for women, the male Surrealists found, as Aragon put it 'a sense of delinquency, contempt for prohibitions and a taste for havoc'.

Extract from **The Passage de l'Opera** Louis Aragon

The unknown is terribly tempting, and danger even more
so. But in its contempt for the instinct of the individual,
modern society has done its best to eliminate both these
phenomena: certainly, under present conditions, the
unknown no longer exists except for those whose emotions
are easily intoxicated, and as for danger, everything visibly
assumes an inoffensive hue each day. And yet in love – love
of all kinds, whether it is this physical fury, or this spectre,
or this diamond-like genie who murmurs to me a name
equivalent to coolness – in all love there resides an outlaw
principle, an irrepressible sense of delinquency, contempt
for prohibitions and a taste for havoc. Confine this hundred-
headed passion within the boundaries of your estates, if
you will, or requisition whole palaces for it: nothing can
stop it surging forth elsewhere, always elsewhere, there
where its appearance is least expected, where its splendour
is an outburst. Best of all, love thrusts up shoots where no
one plants it: how vulgarity convulses it!

↗
Alberto Giacometti
Woman with her Throat Cut 1932
Bronze, 22 x 87.5 x 53.5
Scottish National Gallery of Modern Art,
Edinburgh

↗
René Magritte (detail) 1934

↗↗
Paul Nougé (detail) 1934

René Magritte & Paul Nougé
Words and images

René Magritte & Paul Nougé

The problems posed by representation, visual or verbal, were fundamental to many of the pre-Second World War avant-garde movements, and Surrealism was no exception. Breton believed that the French language had become stagnant. He wanted to liberate it from outdated and tired forms, and believed that by doing so the Surrealists could bring about a revolution in the way we perceive the world. For the Surrealists a revolution in perception would bring about a genuine social and political revolution. As a group of writers, Breton and his colleagues initially turned to their own medium, words and language, as their first point of attack.

Recent studies in linguistics, such as those carried out by the Swiss linguist Ferdinand de Saussure (1857–1913), were an important influence upon the Surrealists' investigation of language. In Saussure's influential *Course in General Linguistics*, given at the University of Geneva between 1906 and 1911 (first published posthumously in 1915), he had proposed that language is made up of an arbitrary system of signs; for example, the word 'tree' designates an oversized plant, or 'cup' an object to drink from. Words have no genuine relation to the objects themselves but function within an interrelated system that governs and shapes our understanding of the world. These theories undermined the tradition of 'nominalism', where a word is equivalent to the thing it describes, and suggested that language is simply another system of interpretation. Saussure's ideas offered tremendous freedom to the Surrealists, who wished to overthrow traditional or fixed systems of understanding the world. Their task was to investigate the relationship between language and experience, and to discover new and liberating ways of communicating.

The Belgian Surrealist group showed a particular interest in the problem of representation. The pre-eminent member of the group, the painter René Magritte, was fascinated by the relationship between language and imagery, publishing his definitive essay on the subject, 'Words and Images', in the Surrealist journal *La Révolution surréaliste* in 1929 (see pages 82–3). In this aphoristic essay Magritte typically uses simple means to make profound statements, such as: 'Everything points to the fact that hardly any relationship exists between an object and that which represents it'. Cartoon illustrations coupled with simple phrases demonstrate the

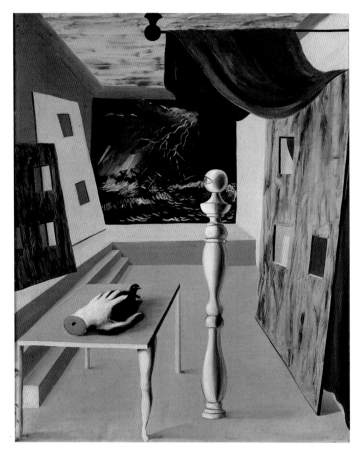

↑
René Magritte
The Difficult Crossing 1926
Oil on canvas, 80 x 65
Jean Krebs Collection, Brussels

complexity involved in representing concrete experience, whether through language or through visual images.

Magritte's interest in the problems of representation was shared by his friend and collaborator Paul Nougé, described as 'the sharpest mind in Belgian Surrealism'. As a writer, poet and political activist, Nougé provided the theoretical framework for many of the Belgian group's activities. He rarely published his writings but made an exception for those on Magritte, producing many articles on his friend's work, culminating in 1943 with his major study, *René Magritte ou les images défendues* (*René Magritte or Images Defended*). So close was their collaboration that at times the authorship of their various projects was confused. This short description, written about Magritte by fellow Surrealist Marcel Mariën, might be said to characterise the work of both men: 'A painter of the commonplace, a philosopher rather than a painter, a poet rather than a philosopher, perpetually preoccupied by basic ideas, it was the essential, elusive reality of a table (for instance) that captivated him'.

Magritte's path to Surrealism, like that of many other artists associated with the movement, began with an exploration of different avant-garde styles and movements. He experimented with abstraction in the manner of Futurism, Cubism and Orphism, but later returned to figurative painting under the influence of Purism. The mechanical precision favoured by Purism, and its admiration for functional, everyday objects, was to leave a lasting impression. In 1925 Magritte was introduced to the work of Giorgio de Chirico, which brought about a turning point in his work. Like Breton and Ernst, Magritte was mesmerised by de Chirico's illogical dreamscapes and the metaphysical presence of his objects. He began to imitate de Chirico's enigmatic spaces, distortions of scale and stage-set compositions. Although Magritte's later work moved away from these crowded compositions to concentrate on simple visual conceits and paradoxes, de Chirico's paintings had revealed a sense of mystery that was to become a guiding principle.

As a student in Brussels Magritte soon became friends with other young pioneers of the Belgian avant-garde, such as the musician E.L.T. Mesens, the writer and poet Marcel Lecomte, and the civil servant and avant-garde dealer Camille Goemans. In 1924

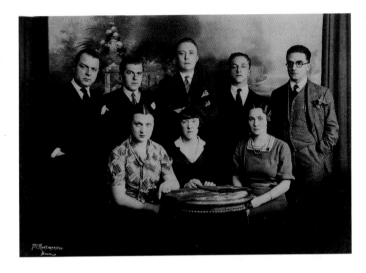

↑
'The Meet': The Brussels Group in 1934
From left, standing E.L.T. Mesens, René Magritte, Louis Scutenaire, André Souris, Paul Nougé; *sitting:* Irène Hamoir, Martha Nougé, Georgette Magritte

they collaborated with Paul Nougé on the publication of a series of provocative tracts called *Correspondance* (1924–5). As challenges to the Paris avant-garde, these came to the attention of Breton and Eluard, and brought about the group's subsequent affiliation to Surrealism. Nougé's sharp mind and intellectual curiosity became the driving force behind the Belgian Surrealist group, which was later joined by Louis Scutenaire, Paul Colinet, André Souris and Marcel Mariën.

In many ways the Belgian group was quite unlike its Parisian counterpart. While Breton and his circle rebelled against their bourgeois backgrounds and disapproved of having a job or pursuing a career, most of the Belgian group continued to live a comfortable middle-class existence with ordinary jobs in public service as civil servants, doctors and teachers. An even greater difference lay in their respective strategies. Unlike the well-publicised and attention-seeking activities of the Parisian group, the Belgians preferred to wage their revolution in secret. Like members of the underworld, they referred to themselves as 'accomplices' and hid their activities behind a mask of bourgeois respectability.

'The subversive act must be discreet,' wrote Nougé, who was the most clandestine of the group. He hated the idea of being a 'writer' and had profound doubts about the value and efficacy of writing altogether. Instead he carried out his role as intellectual *provocateur* on the fringes, and developed such an elusive and self-effacing literary practice that even today it is difficult to trace all his writing.

An attitude of nihilistic contempt, stemming from despair, pervades Nougé's writing, which is by turns provocative and profound. Surprise was an important element in his work: he wrote interventions and additions to existing texts (by authors such as Charles Baudelaire and Guy de Maupassant) and also published under deliberately confusing pseudonyms. His most notorious literary affront involved the publication of erotica under the name of the female author of a well-known grammar book, for which Magritte produced the illustrations. In 1928 Nougé wrote the preface to the catalogue of Magritte's first solo exhibition and encouraged the others to sign it as a collective statement.

The group rallied around Magritte, who became the mouthpiece of the movement, providing him with ideas and titles for his paintings. This way of working was familiar to Magritte from his professional experience as a commercial illustrator. He deliberately developed a descriptive, neutral style which reflected his belief that style must be subordinate to an idea or concept:

> I always try to make sure that the actual painting isn't noticed, that it is as little visible as possible. I work rather like the sort of writer who eschews all stylistic effects, so that the only thing the reader is able to see in his work is the idea he was trying to express. So the act of painting is hidden.

Magritte moved to Paris in 1927, to be nearer to the hub of Surrealist activity, and stayed there until 1930. Although Magritte, Nougé and other members of the Brussels group did not subscribe to Breton's belief in psychic automatism, during this period Magritte's works explored related Surrealist themes such as dream and the subconscious. It may be that the proximity to Breton and the other Surrealist poets brought a new awareness of the role of language in the Surrealist revolution, because Magritte now began to introduce words into his paintings. His work became the playground for an investigation of ideas, leading him to say later that 'images, ideas and words are different determinations of a single thing: thought'. His principle aim, he declared, was to render thought visible.

→
René Magritte
The Reckless Sleeper 1928
Oil on canvas, 115.6 x 81.3
Tate, London

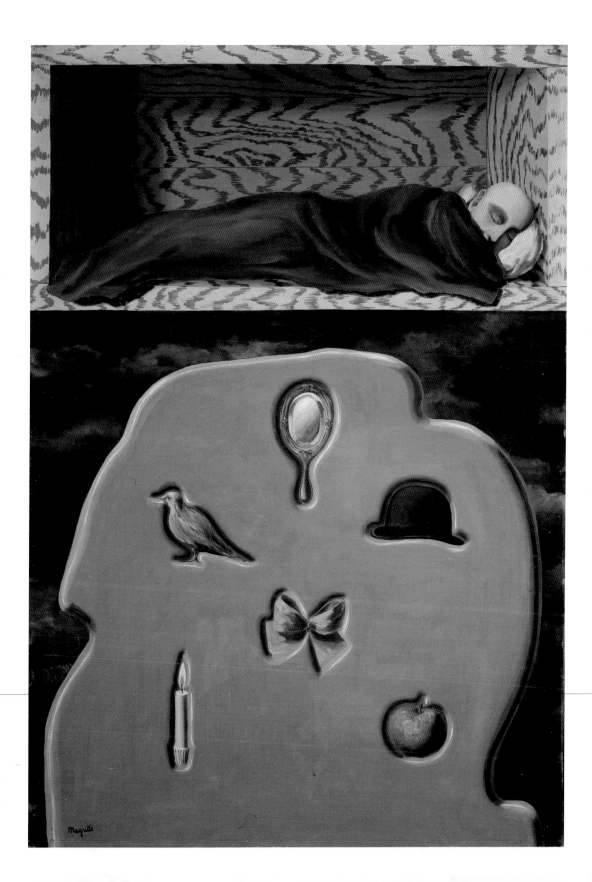

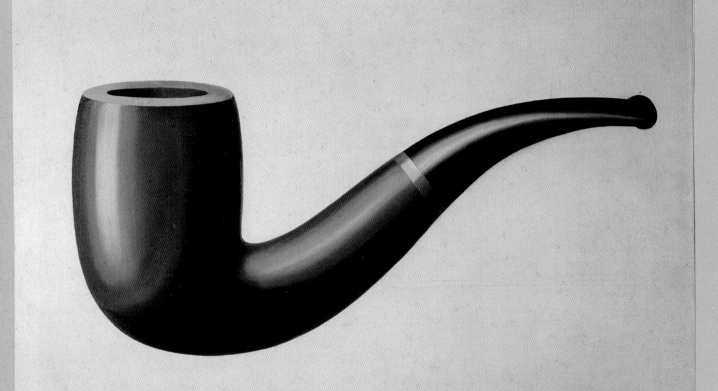

↑
René Magritte
The Betrayal of Images 1929
Oil on canvas, 64.5 x 94
Los Angeles County Museum of Art.
Purchased with funds provided by the
Mr and Mrs William Preston Harrison
Collection

Extract from **René Magritte or Images Defended** Paul Nougé

What are the objects, then, that man should consider most important? Without doubt, those that are most common. The human importance of an object is in direct proportion to its banality.

But this importance can no longer be demonstrated by isolating the object, by removing it from its usual surroundings, or by any similar procedure. The aim is to make contact with the object itself, and to do so in such a way that a kind of enrichment results.

It is in this way that Magritte starts to examine an egg, a door, our gaze, the light, a leaf, a mountain, a house, our hunger, our face, our love.

What sort of question is it that he asks them?

As we know, when a scientist examines an object, he always begins by a process of abstraction that enables him to fit the object into the compass of his science.

Here, it is the real that is envisaged; it is not some aggregate of abstract qualities but the dialectical system of almost infinite richness that a *thing* forms with *ourselves* at the very moment we are considering it. In such a dynamic whole, exchanges take place between innumerable sensory, affective and intellectual sources.

A white patch, a geometrical form, a smooth body, either cold or warm, some food, a pure, fragile being, a source of covetousness or repulsion, the promise of a bird and the bird engendered which engenders the cage according to our desire…

How will the mind tackle this complex? What criterion will it adopt to detect what is essential in it, and to intervene? For Magritte, there is not the slightest doubt.

We must opt for the elements that touch us most directly, most intensely, and which cause the object to become an integral part of our very life.

Here we discover the true primacy of the human, and if destiny has any meaning, we can suddenly catch a glimpse of its face.

We are responsible for the universe.

We must frustrate the tricks of the bird, of hunger, of love, so that the light that deceives us will finally be caught in the trap of the two-way mirror and become the tender, docile servant of our eye.

Magritte's pipe has become one of the iconic images of Surrealism. The success of the work lies in using a simple image to raise a complex problem. It was made in 1929 during Magritte's second year in Paris, probably while he was working on his short but seminal text 'Words and Images', which was published in the December issue of *La Révolution surréaliste* that same year (see pages 82–3). He had begun to introduce words into his paintings during the summer of 1928, shortly after his arrival in Paris. Magritte's apparently sudden interest in the role of language and the relationship between word and image may be linked to his arrival at the centre of Surrealist activity, which was then still dominated by writers and poets. However, this interest must also be linked to his profession as a commercial illustrator. Magritte had worked first as a designer of wallpapers and fabrics, but later he devised advertising imagery for various clients, including the influential Belgian magazine *Variétés*. As an illustrator he developed an ability to blend a concept or phrase with an image in a striking and unconventional manner. From this grew his belief that the medium is subordinate to the message.

The Betrayal of Images depicts an ordinary briar pipe. The style is naturalistic but simplified, evoking the clarity and simplicity of children's picture-books. Beneath the image is the neatly hand-written statement: 'This is not a pipe'. At first glance the painting appears to be creating an amusing paradox, as so many of Magritte's works do, because the statement seems at odds with the manifestly clear image of a pipe. The statement is, of course, entirely correct. This is not a pipe at all but the image, or representation, of a pipe. The image is two-dimensional, simplified and larger than the size of a pipe – facts which lead to the conclusion that this image bears no 'real' relation to a pipe at all.

In addition to this, Magritte also asks us to consider the validity of language. Why should the word 'pipe' be any closer to the real object than the image? Although Magritte may not have read Ferdinand de Saussure's *Course in General Linguistics*, his short text 'Words and Images' investigates similar themes. In this work Magritte points out: 'No object is so inextricably linked to its name that one could not give it another name that would suit it better.' Like Saussure, Magritte seems to conclude that language is arbitrary and that words only have meaning within a defined and agreed system. It is only because we accept that the word 'pipe' designates a wooden smoking instrument that the word has meaning. In the same text Magritte presents a related scenario: 'An object comes into contact with its image; an object comes into contact with its name. The image of the object and its name meet each other.' Beneath is a drawing of a forest with the word 'forest' written next to it. Each symbol, Magritte shows, is interchangeable. As in *The Betrayal of Images* Magritte presents the fundamental problem of representation – how can the world be effectively described or depicted when there is no genuine relation between object, word and image?

For the Surrealists, these theories about language offered a new and revolutionary freedom. Language was no longer seen as a fixed truth, but as something that is potentially unstable and dependent on human interpretation. In other word-paintings of this period, such as *The Use of Speech* (1928), Magritte experimented with attaching words to unidentifiable, indistinct shapes. Two brown, faeces-like patches are accompanied by the text 'mirror' and 'body of a woman'. White flecks float against a wavy, brown background that bears a close resemblance to wood-grain. Aided by the words, we can begin to interpret, or 'read', the image, despite the fact that it bears no obvious resemblance to what the words suggest. It is left up to the power of the imagination, provoked by the mystery of the image. As Nougé argues in his essay about Magritte's work, understanding the object does not come from an aggregation of scientific facts, but from a personal response and the suspension of disbelief.

↑
René Magritte
The Use of Speech 1928
Oil on canvas, 54 x 73
Galerie Rudolf Zwirner, Cologne

The Overturned Mirror Paul Nougé

Somebody kicked the window pane; the glass shattered and we found ourselves elsewhere, in the midst of a coolness to which we were unaccustomed. The skin of our faces and hands told us something of this new world which by degrees revealed itself to be the most extensive, the most finely differentiated, the most satisfying conceivable.
We had our clothing; but some of the unclothed women let out a long cry of ecstasy.
We recognised that cry from having already heard it, less powerful, less decisive, in other circumstances. It came to us, strangely modulated, as if through very deep water.
Our eyes remained obstinately closed, our legs totally failed us.
We resigned ourselves, until the first anguished word which changed the landscape.

The Problematic Spectacle Paul Nougé

Voices were disputing behind a paper screen which closed off the room but allowed the light to filter through; the entanglement of raging shadows.
We were waiting. A shadow took on such a clarity that we believed it was about to pierce the translucent surface, leap into the other world, fall upon us. But it touched the wall and vanished. It was a woman.
The other, arms to its sides, seemed for a moment to be getting a grip on itself, to be asserting itself, to be remaining there. But then we saw it disintegrating at the edges, an acid light eating into it, burning it without flames, and, slight, fragile, disappearing in its turn.
The empty screen then slowly changed colour.
A whitewashed wall gleamed feebly, and was eventually extinguished.
When the darkness was complete, somebody opened a window. We then leant out of the window to see a beautiful pink insect arriving from the farthest distance, shaded from the bright light by a sheet of white paper.

←
René Magritte
The Human Condition 1933
Oil on canvas, 100 x 81
National Gallery of Art, Washington.
Gift of the Collectors Committee

The central paradox of Magritte's startling painting, *The Human Condition*, is summed up in Paul Nougé's aphorism: 'nothing makes the reality of space so uncertain as the painting of reality.' In this work Magritte depicts a painting standing on an easel against a window. The painting (in the painting) shows an image of a landscape that merges with the landscape outside the window. On a straightforward level the work seems to suggest that the landscape painting (in the painting) has been painted by looking out at the exterior landscape, from inside the house. However, Magritte's deceptive *trompe l'oeil* introduces elements of doubt: the painting merges too seamlessly with the landscape behind, creating uncertainty about space and depth. Perhaps there is no easel, and the painting and landscape are one and the same? Or is the interior painting concealing something in the landscape behind? The work raises questions that are fundamental to the problem of representation and the ancient debate about illusion and reality.

Magritte began to use the motif of the 'picture within a picture' after his introduction to the work of the Italian meta-physical painter Giorgio de Chirico in 1925. This subsequently became a central motif, which he explored in different ways throughout the late 1920s and early 1930s. Magritte often uses the picture within the picture as a framing device, emphasising and questioning the illusory nature of the image within it. He also plays with the possibilities of the picture frame as both a container and a window onto another world. In the early 1930s Magritte simplified his compositions and began to focus on single visual conceits or paradoxes. These can be seen as a visual parallel to Breton and the other Surrealists' concept of the 'chance encounter' or the principle of unorthodox juxtaposition. Magritte's images do more than shock and surprise, however. They are essentially investigations in which he deliberately constructs conundrums or puzzles to examine hypothetical, quasi-philosophical problems.

In *The Human Condition* Magritte was responding to what he described as the 'problem of the window'. In a lecture given in 1938 he explained:

> The problem of the window gave rise to 'The Human Condition'. In front of a window seen from inside a room, I placed a painting representing exactly that portion of the landscape covered by the painting. Thus, the tree in the picture hid the tree behind it, outside the room. For the spectator, it was both inside the room within the painting and outside in the real landscape. This simultaneous existence in two different spaces is like living simultaneously in the past and in the present, as in cases of *déjà-vu*.

Magritte sees the painting as solving the problem posed by Surrealism of bringing together 'distant realities'. Here he merges exterior and interior, the real and the painted image, past and present. For the Surrealists this had the added implication of bringing together exterior and interior worlds, the waking, rational mind and the unconscious. A similar drawing together of distant realities is present in Nougé's prose pieces in *Optics Unveiled*. As the title suggests, the writing continually undermines fixed ideas about how we perceive the world: shadows give way to solid images and solid objects disintegrate or fade. A related painting, *The Key to the Fields*, takes as its title a phrase used by the Surrealists to suggest a liberation from physical or mental constraints. It depicts a broken pane of glass that retains an image of the landscape, suggesting the existence of parallel realities. In 'The Overturned Mirror' Nougé describes the same phenomenon: 'the glass shattered and we found ourselves elsewhere'.

→
René Magritte
The Key to the Fields 1936
Oil on canvas, 80 x 60
Museo Thyssen-Bornemisza, Madrid

René Magritte & Paul Nougé

↗
Man Ray
Salvador Dalí (detail) 1929

Salvador Dalí
Painter, poet, paranoiac

Salvador Dalí remains probably the best known of the Surrealist group. His talent for self-promotion and showmanship propelled Surrealism to international fame and secured his own place as the pre-eminent Surrealist artist. When Dalí joined the Surrealist ranks, in 1929, other members of the group had been engaged in Surrealist or proto-Surrealist activity for nearly a decade. It was over five years since Breton had written his first *Manifesto of Surrealism* and the movement had recently taken a dramatic change of direction. Breton was about to signal this change in his second manifesto and was engaged in disputes with other members of the group over the question of Surrealism's adherence to Communism. Dalí created a burst of new energy in the midst of this crisis, prompting Breton to write later: 'For three or four years Dalí was an incarnation of the Surrealist spirit and made it shine with all its brilliance as only someone could who had not played any part in the episodes, sometimes thankless, of its gestation.'

In his autobiography Dalí stressed that his introduction to Sigmund Freud's writings on dream and the unconscious as a student in Madrid had been one of 'the capital discoveries of my life'. Introspective by nature, Dalí was 'seized with a real vice of self-interpretation' and began to use the canvas as an arena for exploring internal dilemmas and anxieties. Among these was a neurosis about his sexuality. The intimacy of his friendship with the poet Federico García Lorca, whose homosexual advances Dalí repeatedly rejected, raised ambiguities about his sexuality that he buried in auto-eroticism. Masturbation became Dalí's main source of sexual pleasure, but it was also the source of crippling anxiety and shame. It was not until 1929, when Dalí met Gala Eluard, who became his lifelong companion, that he was able to come to terms with his sexual neuroses and desires.

During the years leading up to his joining the Surrealist group, writing played an important role in the development of Dalí's ideas. Through his friendship with Lorca he developed an appreciation of poetry that led him to see painting and poetry as parallel means of expression. In his paintings and poems of the mid-1920s, such as *Little Ashes* (1927–8) and 'Poem of the Little Objects' (1927), he used an interchangeable visual–verbal vocabulary that included severed hands, flying breasts and rotting donkeys, among other explicitly Freudian symbols. Dalí's style also suggests the translation of poetic devices onto canvas – cluttered imagery, elusive and illogical narratives and minute attention to detail – although Dalí was dismayed by the conformity of most poetry. 'Don't you think', he wrote to Lorca in 1927, 'that the only poets, the only ones to realise a new poetry are we, the painters?'

It was also through writing that Dalí was able to position himself within the avant-garde arts scene and pave his way to Surrealism. Certain arts periodicals had an international circulation, and just as Dalí learned about Surrealism through influential journals such as the Barcelona-based *L'Amic de les Arts*, he was able to advertise his own ideas and affiliations through the same means. When Dalí joined the Surrealists, he continued to write prolifically for their various publications. His debut piece in Breton's new journal *Le Surréalisme au service de la révolution*, 'The Rotten Donkey' (1930), launched his influential theory of 'paranoiac-criticism':

> I believe that the moment is at hand when, by harnessing the paranoiac and active component of our thinking processes, it will be possible (simultaneously with automatic procedures and other passive states) to systematise confusion and contribute to the total discrediting of the world of reality.

Dalí's paranoiac-critical method attempted to capture the states of heightened awareness or sensitivity experienced by sufferers of paranoia through the use of double or multiple imagery. In this way one image could at the same time be read as something else, with neither interpretation being more valid. For Dalí this was linked to the excavation of the unconscious in Freudian psychoanalysis and thereby to the Surrealist project of 'discrediting the world of reality'. To illustrate the theory, Dalí published a postcard showing an African village which, if attuned to paranoiac-critical thinking, can also be read as a head in profile (see page 98). Breton even interpreted the image as a portrait of the Marquis de Sade.

Breton hailed paranoiac-criticism as 'an instrument of primary importance' and the exercise of the method became a

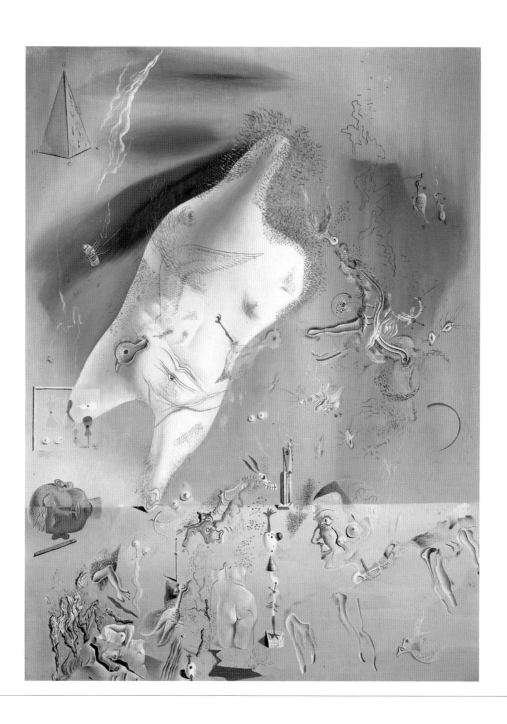

↗

Salvador Dalí
Little Ashes 1927–8
Oil on canvas, 64 x 48
Museo Nacional Centro de Arte Reina
Sofia, Madrid

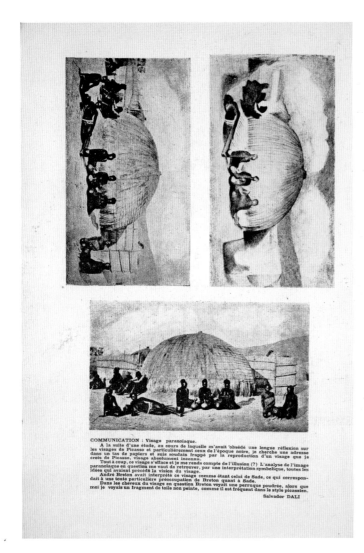

COMMUNICATION : Visage paranoïaque.

 A la suite d'une étude, au cours de laquelle m'avait 'obsédé une longue réflexion sur les visages de Picasso et particulièrement ceux de l'époque noire, je cherche une adresse dans un tas de papiers et suis soudain frappé par la reproduction d'un visage que je crois de Picasso, visage absolument inconnu.

 Tout à coup, ce visage s'efface et je me rends compte de l'illusion (?) L'analyse de l'image paranoïaque en question me vaut de retrouver, par une interprétation symbolique, toutes les idées qui avaient précédé la vision du visage.

 André Breton avait interprété ce visage comme étant celui de Sade, ce qui correspondait à une toute particulière préoccupation de Breton quant à Sade.

 Dans les cheveux du visage en question Breton voyait une perruque poudrée, alors que moi je voyais un fragment de toile non peinte, comme il est fréquent dans le style picassien.

Salvador DALI

new focus for Surrealist activity in the early 1930s. In contrast to the passive techniques of automatism and recording dreams advocated by the first manifesto, paranoiac-criticism contributed to a more active phase of Surrealist practice. Another objective of this phase was to make 'concrete realisations of dream and of irrationality' in the form of Surrealist objects, of which Dalí also became the champion. The Surrealists, like the Cubists and Dadaists before them, were attracted to the enigmatic and subversive resonance of certain objects (such as those found in flea markets). In 1929 *Les Amics de les Arts* published an article by Dalí entitled 'Surrealist Objects. Oneiric Objects', a theme he later developed in 1931 when he wrote a 'catalogue' of the different categories of Surrealist objects: 'Symbolically Functioning Objects (automatic origin); Transubstantiated Objects (affective origin); Objects for Hurling (dream origin); Enveloped Objects (daytime fantasy)'. As is the case with Dalí's famous *Lobster Telephone* (1936), Surrealist objects often rely on the principle of unexpected juxtaposition 'so that reality may begin to assume the dreamed of aspects'.

Dalí's ability to translate his ideas into a variety of different forms, including painting, poetry, essays, film, objects and, of course, life, was one of his greatest strengths. This cross-fertilisation continued to feed and inspire his work, even when he turned away from Surrealist principles in the late 1930s.

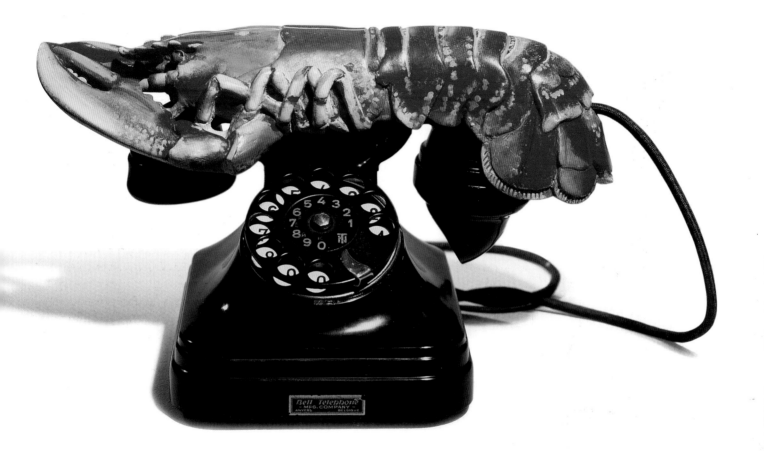

↑
Salvador Dalí
Lobster Telephone 1936
Plastic, painted plaster and mixed media,
17.8 x 33 x 17.8
Tate, London

↖
Salvador Dalí
'Communication: Visage paranoïaque' 1931
Le Surréalisme au service de la révolution no.3,
December 1931

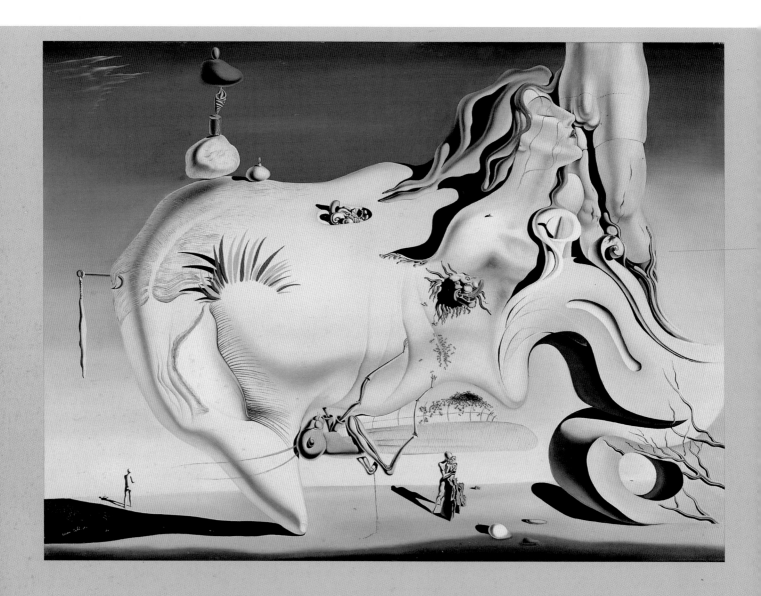

↑
Salvador Dalí
The Great Masturbator 1929
Oil on canvas, 110 x 150
Museo Nacional Centro de Arte Reina
Sofia, Madrid

Extract from **'The Great Masturbator'** Salvador Dalí

Despite the reigning darkness
the evening was still young
near the great stairway houses of agate
where
tired by the daylight
that lasted since sunrise
the Great Masturbator
his immense nose reclining upon the onyx floor
his enormous eyelids closed
his brow frightfully furrowed with wrinkles
and his neck swollen by the celebrated boil seething with
ants
came to rest
steeped in this still too luminous time of the evening
while the membrane covering his mouth entirely
hardened alongside the alarming the eternal grasshopper
stuck clinging motionless to it
for five days and nights.

All the love and all the ecstasy
of the Great Masturbator
resided
in the cruel ornaments of false gold
covering his delicate and soft temples
imitating
the shape of an imperial crown
whose fine leaves of bronzed acanthus
reached as far
as his rosy and beardless cheeks
and extended their hard fibres
until they dissolved
in the clear alabaster of his neck.

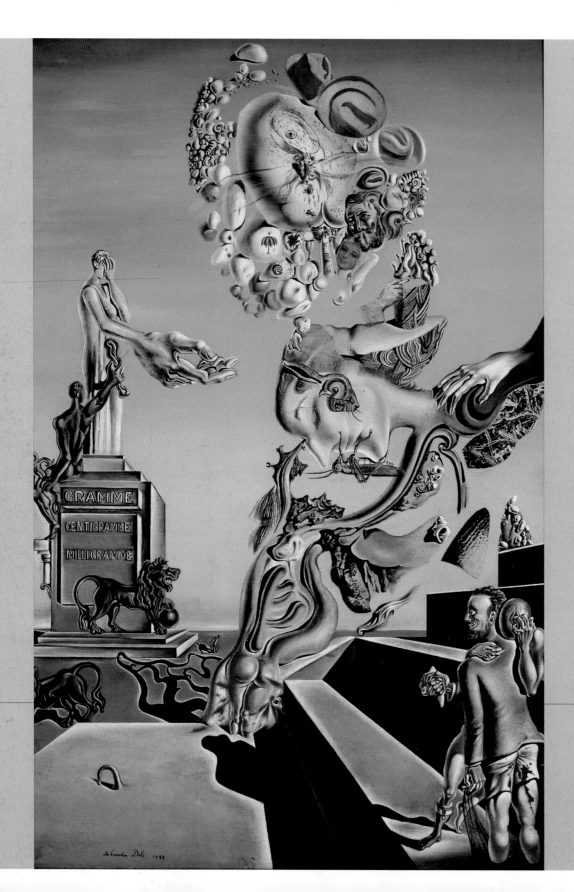

The Lugubrious Game was painted at a crucial moment of Dalí's life. In the early summer of 1929 he left Paris, where he had been working on the film *Un chien andalou* with Luis Buñuel, and returned to his family holiday home at Cadaqués. Exhausted by his stay in Paris, Dalí underwent a period of regression and was seized by hallucinations and fits of hysteria. In his autobiography he described how he imagined 'infinite images' from his child-hood, and wrote:

> I also saw more complicated and condensed images: the profile of a rabbit's head, whose eye also served as the eye of a parrot, which was larger and vividly coloured. And the eye served still another head, that of a fish enfolding the other two. This fish I sometimes saw with a grasshopper clinging to its mouth.

This description clearly relates to *The Lugubrious Game*, which Dalí began to paint that summer, and into which he 'poured body and soul'. In the centre of the painting, as he describes, there is the double image of a parrot embedded in a rabbit's head, which also forms the ear of a man's face in profile. The head in profile with a grasshopper attached to its lips is a frequent motif in his paintings of 1929–30 and is commonly known as 'The Great Masturbator' after a painting of this title in which a huge version of the head dominates the canvas (see page 100). It is generally considered to be a self-portrait, and the grasshopper refers to Dalí's childhood phobia of the insect. This motif became the starting point for a poem, also called 'The Great Masturbator', which was included in Dalí's first book, *La Femme visible* (*The Visible Woman*), published by Editions Surréalistes in 1930. This poem, like *The Lugubrious Game*, is a repository of Dalí's sexual obsessions and anxieties at that time, which spill indiscriminately into his painting and poetry.

Both the poem and the motif of 'The Great Masturbator' refer to Dalí's compulsive habit of masturbation, which was as much a source of shame as of pleasure. The painting depicts several images that draw upon Freudian imagery assoc-iated with impotence, masturbation and the fear of castration. The figure on the pedestal covers his face in shame while holding out an enlarged hand, symbolic of his guilty act, to receive a stone-like phallus (which could double as a vulva) passed to him by a figure below. On the right, a bearded father-figure holds a bloody handkerchief which suggests that he may have castrated the youth who leans against him, also covering his face. If these images represent Dalí's fears, the flow of images in the centre of the painting, and those emanating from the masturbator's head, may represent his fantasies and desires. A fleshy female bottom flows into art nouveau swirls and arabesques, a style that Dalí associated with uninhibited desires, rising into boulders and shells which have further echoes of buttocks and breasts. The most dominant motif, however, is that of the vulva, the lips of female genitalia, which appear with terrifying ubiquity, as the livid red mouth of the bearded man (top right), in the head of the castrated youth, and in the clefts of the numerous floating hats.

Painted just before the arrival of Gala, the woman who was to be Dalí's first lover and later his wife, *The Lugubrious Game* overflows with images suggesting his obsession with the female body, as well as his fear of it, and shame at his onanism. The title of the painting was suggested by Gala's first husband, Paul Eluard, when they arrived later that summer to spend a holiday with Dalí in Cadaqués. Gala subsequently took the painting back to Paris, where it was the star of Dalí's debut Paris exhibition in November 1929.

←

Salvador Dalí
The Lugubrious Game 1929
Oil and collage on cardboard, 44.4 x 30.3
Private collection

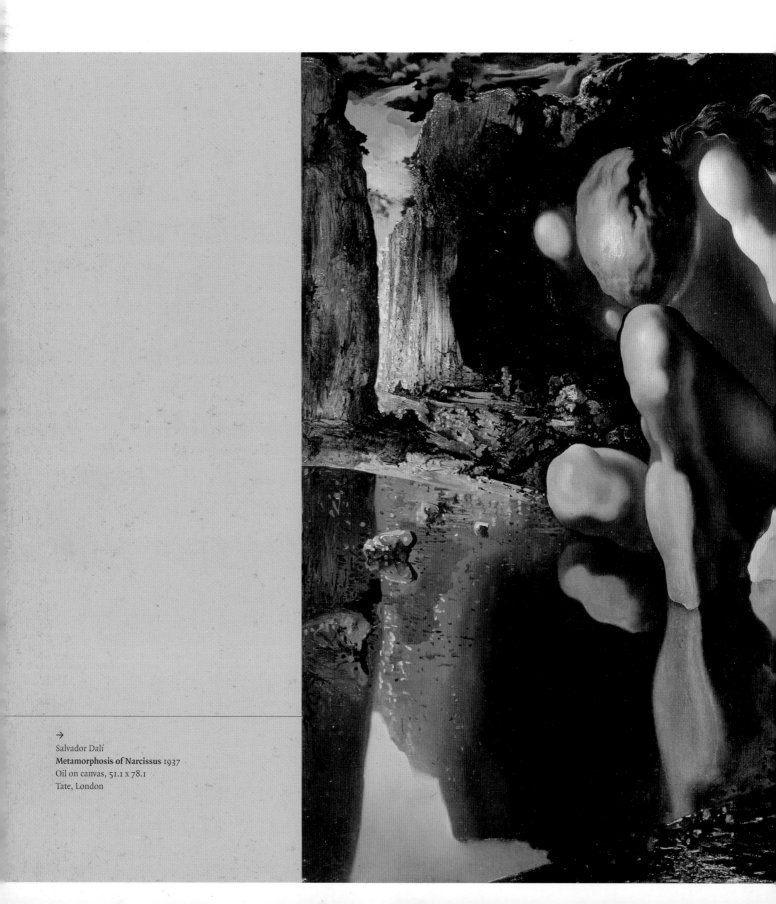

→
Salvador Dalí
Metamorphosis of Narcissus 1937
Oil on canvas, 51.1 x 78.1
Tate, London

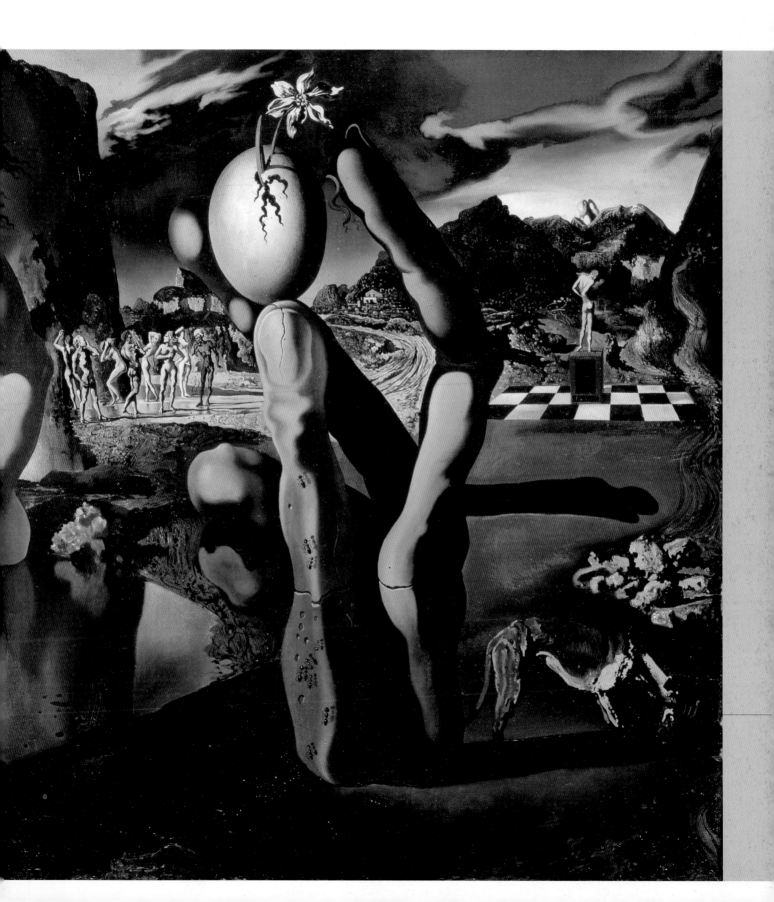

The Metamorphosis of Narcissus Salvador Dalí

Under the split in the retreating black cloud
the invisible scale of Spring
is oscillating
in the fresh April sky.
On the highest mountain,
the god of snow,
his dazzling head bent over the dizzy space of reflections,
starts melting with desire
in the vertical cataracts of the thaw
annihilating himself loudly among the excremental cries of
minerals,
or
between the silences of mosses
towards the distant mirror of the lake
in which,
the veils of winter having disappeared,
he has newly discovered
the lightning flash
of his faithful image.
It seems that with the loss of his divinity the whole high plateau
pours itself out,
crashes and crumbles
among the solitude and the incurable silence of iron oxides
while its dead weight
raises the entire swarming and apotheosic
plateau from the plain
from which already thrust towards the sky
the artesian fountain of grass
and from which rise,
erect,
tender,
and hard,
the innumerable floral spears
of the deafening armies of the germination of the narcissi.

Already the heterosexual group, in the renowned poses of
preliminary expectation, conscientiously ponders over the
threatening libidinous cataclysm, the carnivorous blooming
of its latent morphological atavisms.

In the heterosexual group,
in that kind date of the year
(but not excessively beloved or mild),
there are the Hindou
tart, oily, sugared
like an August date,

the Catalan with his grave back
well planted
in a sun-tide,
a whitsuntide of flesh inside his brain,
the blond flesh-eating German,
the brown mists of mathematics
in the dimples
of his cloudy knees,

there is the English woman,
the Russian,
the Swedish women,
the American
and the tall dark Andalusian,
hardy with glands and olive with anguish.

Far from the heterosexual group, the shadows of the advanced
afternoon draw out across the countryside, and cold lays hold of
the adolescent's nakedness as he lingers at the water's edge.

When the clear and divine body of Narcissus
leans
down to the obscure mirror of the lake,
when his white torso folded forward
fixes itself, frozen,
in the silvered and hypnotic curve of his desire,
when the time passes

on the clock of the flowers of the sand of his own flesh,

Narcissus loses his being in the cosmic vertigo
in the deepest depths of which
is singing
the cold and dionysiac siren of his own image.
The body of Narcissus flows out and loses itself
in the abyss of his reflection,
like the sand glass that will not be turned again.

Narcissus, you are losing your body,
carried away and confounded by the millenary reflection of your
disappearance
your body stricken dead
falls to the topaz precipice with yellow wreckage of love,
your white body, swallowed up,
follows the slope of the savagely mineral torrent
of the black precious stones with pungent perfumes,
your body . . .
down to the unglazed mouths of the night
on the edge of which
there sparkled already
all the red silverware
of dawns with veins broken in 'the wharves of blood'.

Narcissus,
do you understand?
Symmetry, divine hypnosis of the mind's geometry, already
fills up your
head,
with that incurable sleep, vegetable, atavistic, slow

Which withers up the brain
in the parchment substance
of the kernel of your nearing metamorphosis.
The seed of your head has just fallen in the water.
Man returns to the vegetable state
by fatigue-laden sleep

and the gods
by the transparent hypnosis of their passions.
Narcissus, you are so immobile
one would think you were asleep.
If it were a question of Hercules rough and brown,
one would say: he sleeps like a bole
in the pasture
of an herculean oak.
But you, Narcissus,
made of perfumed bloomings of transparent adolescence,
you sleep like a water flower.

Now the great mystery draws near,
the great metamorphosis is about to occur.

Narcissus, in his immobility, absorbed by his reflection with
the digestive
slowness of carniverous plants, becomes invisible.

There remains of him only
the hallucinatingly white oval of his head,
his head again more tender,
his head, chrysalis of hidden biological designs,
his head held up by the tips of the water's fingers,
at the tips of the fingers
of the insensate hand,
of the terrible hand,
of the excrement-eating hand,
of the mortal hand
of his own reflection.

When that head slits
when that head splits
when that head bursts,
it will be the flower,
the new Narcissus,
Gala –
my narcissus.

↑
Gala and Dalí 1930
Fundació Gala-Salvador Dalí

Dalí's prolific writing and renewed interest in poetry in the early 1930s prompted him to write a poem to accompany his major painting *Metamorphosis of Narcissus*. Shortly afterwards Dalí published a pamphlet about the painting and the poem where he claimed that they were 'the first poem and the first painting obtained entirely through the integral application of the paranoiac-critical method'. Intended to be seen together, Dalí offered further guidelines on viewing the painting: 'If one looks for some time, from a slight distance and with a certain "distant fixedness" at the hypnotically immobile figure of Narcissus, it gradually disappears until at last it is completely invisible.'

The subject of the painting and poem is the Greek myth about the transformation of Narcissus, a beautiful youth who fell in love with his own reflection and, unable to tear himself away from his own image, died of longing. On his death he was transformed into the flower that bears his name, which is often found growing at the edge of springs. The myth has a rich history in art and literature, and in this painting Dalí chooses the popular depiction of the crouched Narcissus peering down at his reflection in a pool. For Dalí this story had added significance because 'Narcissism' was the name adopted by Sigmund Freud for the psychoanalytic neurosis of 'unbounded self-love'. Dalí often remarked upon his own vanity and self-obsession, and was conscious of his compulsive habit of masturbation. It becomes clear that Dalí identified with the figure of Narcissus, and that the painting and poem are an extensive form of self-analysis. It comes as no surprise therefore that this was the painting Dalí chose to show to Freud when he visited him in London in 1938. The meeting was a great success and Freud later wrote that 'it would in fact be very interesting to investigate analytically how a picture like this came to be painted'.

In *Metamorphosis of Narcissus* Dalí compresses the whole story into one scene. On the left is the crouching figure of Narcissus with his head on his knee, and mirroring him on the right is a rock formation in the shape of a hand holding an egg. Away from the crowd in the background, the self-obsessed Narcissus stands on a pedestal admiring his body. In the far distance snowy peaks indicate the changing of the seasons; the clouds in the top right give way to blue sky and sunshine in the top left of the painting. In the poem the changing weather and landscape are a metaphor for the youth's changing body as he undergoes transformation into a flower. The narcissus flower, which grows in the spring, and the egg, symbolise the start of new life.

Dalí explains in the pamphlet's preface that in Catalan the word for a psychoanalytic 'complex' literally means 'a bulb in the head'. Here the bulb-head hatches into the narcissus flower, which as Dalí says at the end of his poem is 'Gala – my narcissus'. Since Dalí identifies himself with the figure of Narcissus and his wife with the narcissus flower, then the painting implies that Dalí's personal transformation is through his wife, Gala. Dalí's relationship with Gala was very close and with her help he overcame many personal neuroses, including his shame about masturbation. From this painting onwards, Dalí promoted his unity with his wife by signing all his works 'Dalí-Gala'.

Louis Aragon (1897–1982)

Aragon was a poet, novelist and essayist who later became a political activist and spokesman for Communism. He was born in an affluent suburb of Paris under the name Louis Andrieux, but later adopted his maternal grandmother's surname. He trained in medicine and met André Breton as a student at the Val-de-Grâce military hospital in 1917. They shared a mutual interest in poetry and, through Breton, Aragon was introduced to members of the literary avant-garde. In 1919 they founded the proto-Surrealist review *Littérature* with Philippe Soupault and briefly joined Dada. In 1920 Aragon published his first volume of poetry, *Feu de joie*, followed by *Le Mouvement perpétuel* in 1925. Just prior to this, in 1924, he published a series of provocative texts called *Le Libertinage* (1924). His novel *Le Paysan de Paris*, which was written between 1924 and 1926, is one of the most famous pieces of Surrealist writing.

In 1927 Aragon joined the Communist party, and the following year he met the Russian revolutionary writer Elsa Triolet, who became his wife and inspiration. Unlike other Surrealists, Aragon began to view Communism as the only means towards social and political revolution and this belief increasingly influenced his artistic and literary expression. In 1930 he visited the Soviet Union as a delegate to the Kharkov Conference of Revolutionary Artists and Writers, drawing him further away from Surrealist principles. In 1932 Aragon published a propagandist poem and was prosecuted for sedition, although charges were eventually dropped. Known as the 'Aragon Affair', this episode brought about his final break with the Surrealists in 1932. Aragon became an official spokesman for Communism and, adopting a Socialist Realist style, he wrote a number of novels about the struggle of the proletariat. These include the four-volume series *Le Monde réel* (1933–44) and *Les Communistes* (1949–51).

Aragon participated in the resistance movement during the Second World War, and wrote patriotic volumes of poetry such as *Le Crève-Coeur* (1941). He also wrote several novels containing veiled autobiography, including *La Mise à mort* (1965) and *Blanche ou l'oubli* (1967), and published poetry expressing his deep affection for his wife: *Les Yeux d'Elsa* (1942) and *Le Fou d'Elsa* (1963). From 1953 to 1972 Aragon was editor of the Communist review *Les Lettres françaises*. He was made a member of the French Legion of Honour in 1981.

André Breton (1896–1966)

Breton was the leader of Surrealism and a major figure of twentieth-century French literature. He was born in Tinchebray in northern France and, after hearing a poem by Stéphane Mallarmé at school, he resolved to become a poet. He was persuaded to study medicine by his family, and through his training was introduced to Freud's theories of the unconscious. In 1919, under the influence of Dada, Breton started the review *Littérature* with Louis Aragon and Philippe Soupault. In this they published excerpts of *Les Champs magnétiques* (1919), a collaboration between Breton and Soupault which was the first example of the Surrealist technique of 'automatic' writing.

In 1924 Breton wrote the first *Manifesto of Surrealism*, which formally introduced the Surrealist movement, and from 1926 he edited the group's new review *La Révolution surréaliste*. Breton went on to write extensively about Surrealism, as well as producing poetry and Surrealist novels. Among his most famous works are *Nadja* (1928), *Les Vases communicants* (1932), *Le Révolver à cheveux blancs* (1932) and *L'Amour fou* (1937). In 1929 he published the second Surrealist manifesto, coinciding with the end of his first marriage to Simone Kahn. He subsequently married Jacqueline Lamba (1934) and finally Elisa Claro (1943).

Breton had a complex relationship with

Salvador Dalí (1904–1989)

politics, and particularly with the French Communist Party. He joined the Party in 1927 but later developed Trotskyist sympathies. During the 1930s Breton gave many international lectures on Surrealism and contributed to various international reviews. In the Second World War he was mobilised as a doctor in Poitiers, but fled to New York during the German occupation. In exile he continued to write poetry and organise exhibitions, while also contributing to American Surrealist reviews. After his return to France in 1946 he kept up Surrealist activities, promoting new artists and helping to establish six different reviews as well as a Surrealist gallery. In 1953 he published *La Clé des champs* and in 1965 he collected his earlier essays on Surrealist painters into one volume, *Le Surréalisme et la peinture*.

Dalí was born in Figueras, a prosperous provincial town in Catalonia. He showed an early gift for art, and established a radical arts journal and wrote art criticism during his teens. In 1921 he was sent to study at the School of Fine Arts, Madrid, and while living at the liberal arts hostel known as 'La Residencia' he met the poet Federico García Lorca and the film-maker Luis Buñuel. Dalí's early Cubist-inspired work was transformed by his discovery of Giorgio de Chirico and the writings of Sigmund Freud. Bizarre objects in dream-like landscapes became his forum for exploring various psychological taboos and fantasies. In 1926 he was expelled from art school and travelled to Paris, where he met Picasso and, later, Miró. During this period he had two solo exhibitions at the Gallery Dalmau, Barcelona, and participated in a group exhibition in Madrid.

In the late 1920s Dalí positioned himself closer to Surrealist ideas and, following his collaboration with Luis Buñuel on the films *Un chien andalou* (1929) and *L'Age d'or* (1930), he was accepted into the movement. In 1929 he met Gala Eluard who became his companion and later his wife. From 1929 until the late 1930s Dalí explored his theory of 'paranoiac-criticism' by producing meticulously painted *trompe l'œil* imagery in an academic style. He developed a

repertoire of images, such as melting clocks, props and telephones, which feature in his most well-known works such as *The Persistence of Memory* (1931). During this period Dalí also developed the concept of the Surrealist object.

From the early 1930s Dalí exhibited regularly in the United States and promoted the movement with a series of flamboyant publicity stunts. However, Dalí's perceived commercialism and his growing right-wing sympathies led to his expulsion from the movement in 1940. His first retrospective was held at the Museum of Modern Art in New York in 1941, and he published *The Secret Life of Salvador Dalí* between 1942 and 1944. During this period his painting began to move towards academic and classical subjects, and he continued to trouble former allies by supporting Fascist causes. From 1950 to 1970 Dalí painted a large number of religious subjects, as well as childhood memories and erotic works. Many of these paintings centre on his wife Gala, who died in 1982.

Paul Eluard (1895–1952)

Paul Eluard was one of the most important French lyric poets of the twentieth century. He was born Eugène-Emile-Paul Grindel in Saint-Denis, a suburb outside Paris. In 1912 he was diagnosed with tuberculosis, which was to recur throughout his lifetime, and was sent to recuperate at a sanatorium in Switzerland. There he met Helena Dimitrovnie Diakonova, nicknamed Gala, who became his wife in 1917. She remained the love of his life despite a tumultuous marriage during which they both had many affairs. In 1929 Gala left Eluard for Salvador Dalí and Eluard met Maria Benz, known as Nusch, an Alsatian woman whom he later married.

Eluard began to write poetry in 1913 and had published several volumes before meeting André Breton, Philippe Soupault and Louis Aragon in 1919. He joined the Dadaists and was later one of the founders of Surrealism in 1924. His first important work was *Capitale de la douleur* (1926), which was followed by his intensely romantic exploration of love in *L'Amour la poésie* (1929).

Eluard joined the Communist Party along with other members of the Surrealist group in 1927, but his committed political awakening took place during the 1930s. His volumes of poetry *La Vie immédiate* (1932) and *La Rose publique* (1934) are still essentially Surrealist works, but from the mid-1930s his writing began to reflect his fear of fascism and war, shown in poetic volumes such as *Les Yeux fertiles* (1936) and *Donner à voir* (1939). Eluard left Surrealism definitively in 1938 and became an active member of the resistance movement during the Second World War, writing propagandist poetry about hope, struggle and freedom. These are gathered in *Poésie et verité* (1942) and *Au rendez-vous allemand* (1945). Nusch's sudden death in 1946 left Eluard devastated and, after a period of intense melancholy, he married Dominique Lemor, who outlived him. His most important post-war work was *Pouvoir tout dire* (1951).

Max Ernst (1891–1976)

Ernst was born in Brühl, Germany and studied psychology and philosophy at Bonn University, where he developed an interest in the art of the mentally ill. In 1911 he abandoned academic study for painting. He had no formal training but was initially influenced by Expressionism, through his friend August Macke. Ernst served in the artillery in the First World War, returning with a powerful sense of rebellion. He settled in Cologne and, with his friend Hans Arp, he started a Cologne Dada group.

From 1919 Ernst experimented with collage, and produced a series of pioneering images called *Fiat Modes. Pereat Ars.* The following year he co-organised one of Dada's most notorious exhibitions at a restaurant in Cologne. In 1921 the Paris Dadaists organised an exhibition of his collages in Paris and he later collaborated with Paul Eluard on two books. He moved to Paris in 1922, where he settled with the Eluards, and immediately joined the Paris Dada group, going on to become a founding member of Surrealism in 1924. In the early 1920s Ernst moved from collage to painting, evolving an enigmatic style influenced by Giorgio de Chirico, and produced several of the major Surrealist 'dream' paintings, such as *Celebes* (1921). Many of these reveal Ernst's fascination with psychology and Freudian analysis. He

Alberto Giacometti (1901–1966)

married Marie-Berthe Aurenche in 1927.

Ernst was a pioneer of 'automatic' techniques in painting, and invented the semi-automatic methods of *frottage* and *grattage* in 1925. These techniques inspired the collection of drawings *Histoire Naturelle* (1926) and the bizarre 'forest' and 'horde' paintings of the late 1920s, which often feature his alter ego, the bird Lop-Lop. Ernst produced three collage novels from 1929 to 1934, and in 1935 he made his first sculpture, after which he concentrated further on this medium. In 1937 Ernst moved to the South of France with his new companion, the English painter Leonora Carrington.

Ernst was imprisoned at the outbreak of the Second World War, but escaped to New York in 1941. There he was supported by Peggy Guggenheim, who became his third wife, and during the 1940s he produced paintings that were inspired by the semi-automatic technique of *décalcomania*. In 1946 he settled in Arizona with his fourth wife, the American painter Dorothea Tanning, where he was inspired by native American art. In 1952 they relocated to France. Two years later Ernst won the Grand Prize at the Venice Biennale, and he was subsequently given a number of major international retrospective exhibitions. Ernst accepted French citizenship in 1958.

Giacometti was one of the most influential and original sculptors of the twentieth century. He was born in Borgonovo, in the Italian-speaking region of Switzerland, where he grew up in an artistic household. His father was a Post-Impressionist painter and his uncle the Fauvist painter Cuno Amiet. Giacometti studied at the Ecole des Beaux-Arts and the Ecole des Arts Industriels in Geneva before moving to Paris in 1922. There he enrolled in Emile Bourdelle's classes at the Académie de la Grande Chaumière. Bourdelle had assisted Auguste Rodin and Giacometti's style subsequently reflected Rodin's expressionistic naturalism. By the mid-1920s, however, Giacometti had abandoned naturalism in favour of sculpture influenced by Cubism, and African and Oceanic art. He flattened busts and heads into a series of 'plaque' sculptures, and later developed a style of 'openwork' sculpture.

From 1929 Giacometti began to be closely associated with Surrealism: his work was illustrated in Surrealist reviews and he also contributed articles. Sex and violence became prominent themes in his work of this period, notably in *Woman with her Throat Cut* (1932). His first solo exhibition was held at the Galerie Pierre Colle in 1932. Giacometti participated in Surrealist exhibitions, but in 1934 he started working

again from a life model rather than from the imagination, and he was expelled from the movement. During the same year he had a solo exhibition at the Julien Levy Gallery in New York. Giacometti began now to make a series of portrait busts from models, often his brother Diego, working his material so intensely that the image began to emaciate.

He spent the Second World War in Geneva to escape German occupation and then returned to Paris. The post-war years saw the emergence of his mature style, which featured gaunt figures or busts with dramatically elongated frames. These figures seemed to capture the loneliness of human existence and became associated with the existential philosophy of Jean-Paul Sartre, who wrote about his work. Giacometti moved from small-scale works to large, monumental sculptures, culminating in the huge, striding figures that he produced (but never installed) as a commission for the Chase Manhattan Bank in New York from 1958 to 1960. In 1962 he had a solo exhibition at the Venice Biennale, followed by several major international retrospectives.

Michel Leiris (1901–1990)

Born in Paris, Leiris soon gave up his study of chemistry to become a writer. He met André Masson in 1922, who introduced him to members of the Dada, and subsequently Surrealist, circles. Leiris signed the first *Manifesto of Surrealism* in 1924 and became closely involved in language experiments such as 'automatic' writing. He published his first selection of poetry *Simulacre* (Simulacra) in 1925, with lithographs by André Masson, and went on to write various Surrealist texts during the 1920s. These include *Le Point Cardinal* (1927) and a novel called *Aurora* (1946). In 1929 he broke with Surrealism and co-founded the review *Documents* with the writer Georges Bataille. They shared a fascination for ethnography and anthropology, which led to Leiris's participation in the famous French ethnographic expedition 'Mission Dakar-Djibouti' across North Africa. His extraordinary account of this trip, *L'Afrique Fantôme* (1934) mixes personal reflection with scientific analysis. Leiris was one of the founders of the Collège de Sociologie and later became the director of the Musée de l'homme in Paris. He co-edited the review *Les Temps Modernes* with Jean-Paul Sartre and wrote extensive art criticism. His most important work is his expansive four-volume autobiography *La Règle du Jeu*, which opens with *L'Age d'homme* (translated into English as *Manhood*) (1939). Leiris travelled widely throughout his lifetime and was posted to North Africa during the Second World War. He married Louise Godon in 1926.

René Magritte (1898–1967)

Magritte was born in the provincial town of Lessines in Belgium. He moved to Brussels in 1916 to study at the Académie des Beaux-Arts and during the 1920s he experimented with different avant-garde styles such as Cubism and Orphism. During this period he also worked as a commercial illustrator and designer. In 1922 Magritte married his childhood friend Georgette Berger. In the same year he discovered the work of Giorgio de Chirico, which was a formative influence on his work. It introduced the style for which Magritte has become known, in which a repertoire of unlikely objects, such as a balustrade, a mountain, a castle and a window, recur in enigmatic and illogical settings.

In 1925 Magritte founded the Belgian Surrealist group with his friends Paul Nougé and E.L.T. Mesens. A year later a Belgian gallery began to support his work, giving him the opportunity to paint full time, and he held his first solo exhibition in 1927. Magritte spent the years from 1927 to 1930 in Paris, where he established closer links with the Paris Surrealists. During this period he introduced words and letters into his paintings, and developed an interest in visual paradoxes or conceits executed in an immaculate *trompe l'œil* style. In 1930 he returned to Brussels, where he lived for the rest of his life.

Man Ray (1890–1976)

During his time in occupied Belgium during the Second World War, Magritte began to paint in a lighter, impressionistic style. These paintings caused a break with Breton, exacerbated by the publication in 1945 of a manifesto called *Surréalisme en plein soleil* (*Surrealism in Broad Daylight*), which he co-wrote with other Belgian Surrealists. In the late 1940s Magritte experimented with a crude and colourful style, later dubbed his *'vache'* period, but in the 1950s he returned to reworking previous paintings. Interest in Magritte's work increased enormously in the 1960s and there were two major retrospectives before his death.

Man Ray was born Emmanuel Radnitsky in Philadelphia and grew up in Brooklyn, New York. Man Ray showed an early interest in the arts, but rejected a scholarship to study architecture. Instead he worked as a commercial artist for a publisher of maps and atlases and also took evening classes at the National Academy of Design. In 1911 he enrolled at the Ferrer Center, a radical art college, and became friends with members of the avant-garde, such as Marcel Duchamp. With Duchamp, Man Ray became the main proponent of Dada in New York, producing objects and ready-mades, while continuing to paint and experiment with photography. During this period he lived in an artists' colony at Ridgefield with his wife, the Belgian writer Adon Lacroix.

In 1921 Man Ray left for Paris, where he became friends with the Paris Dadaists and subsequently the Surrealists. He set up a portrait studio and made a living from photographing artists and writers, while continuing Dada and Surrealist activities. His first solo exhibition was held in 1921, and the following year he invented the 'rayograph', a technique of cameraless photography. However, his fame as a portraitist spread and he became an established society photographer. For six years Man Ray lived with the singer Alice Prin,

dubbed 'Kiki of Montparnasse', followed by a three-year relationship with the American photographer Lee Miller. Man Ray and Miller discovered the 'solarisation' technique in 1929.

Several monographs were published on Man Ray's work during the 1920s and 1930s, and he also collaborated on several films, including *Le Retour à la raison* (1923), *Anaemic Cinema* (1924) and *Etoile de mer* (1928–9). In 1940, to escape German occupation during the Second World War, Man Ray moved to California where he met the dancer Juliet Browner, whom he married in 1946. During this period he remade some of his earlier objects, began to paint again and also continued fashion and experimental photography. Man Ray returned to live in Paris in 1950 and was awarded the gold medal at the Venice Biennale in 1961.

Joan Miró (1893–1983)

The Catalan artist Joan Miró was born in Barcelona and lived for much of his life between Paris, where he first went at the age of twenty-eight, and his family's farm at Montroig in the province of Tarragona. His work demonstrated close links with his homeland throughout his lifetime and, although he was exiled during the Spanish Civil War, he painted a large painting in protest, called *The Reaper*, which was exhibited in the Spanish Republican Pavilion at the Paris Exposition Universelle in 1937. After leaving school Miró worked for two years as a book-keeper, which led to a nervous breakdown in 1911, and as a result his parents sent him to art school in Barcelona. He was given his first solo exhibition in Barcelona in 1918, his early work showing the influence of various modern movements, such as Cubism and Fauvism.

Following a move to Paris in 1921, Miró became closely associated with the Surrealists and signed their first manifesto in 1924. He experimented with automatism and, inspired by the painter Paul Klee, worked on a series of 'dream paintings' and 'imaginary landscapes', near-abstract works that rely on symbol and metaphor. Miró returned briefly to figuration at the end of the 1920s, before his 'crisis of painting' in 1929, when he abandoned painting altogether for a short period. In the same year he married Pilar Juncosa.

In the 1930s Miró's reputation became more established and he exhibited internationally. He continued to explore a personal mythology, and his works of this period are imbued with magic and mysticism, but the impending Spanish Civil War provoked a series of dark paintings populated with brutal and aggressive forms. He spent the Second World War mainly in Majorca, where he made the lyrical and optimistic Constellations series.

Miró employed a range of media throughout his career, including collage, prints, tapestry, ceramics and sculpture. Ceramics became an important part of his practice during the post-war years and he executed a number of major commissions. In 1958 he completed a ceramic frieze for the UNESCO building in Paris, for which he was awarded the Great International Prize by the Solomon R. Guggenheim Foundation. He was given his first major retrospective at the Museum of Modern Art in New York in 1959 and, following further honours and retrospectives, he was awarded Spain's Gold Medal of Fine Arts in 1980.

Paul Nougé (1895–1967)

Nougé was the leading theorist of Belgian Surrealism and a founder member of the Communist Party in Belgium, established in 1919. Born in Brussels, he trained as a biochemist, a profession he continued throughout his life, but his real passion was literature and the pursuit of ideas. Between 1924 and 1925 Nougé edited a review called *Correspondence* with Camille Goemans and Marcel Lecomte, which came to the attention of the Paris Surrealists and led to the formation of a Belgian Surrealist group. In the 1920s and 1930s Nougé contributed a number of articles to Surrealist journals and wrote extensively about the work of his close friend René Magritte. In 1927 he published *Quelques écrits et quelques dessins de Clarisse Juranville*, a scandalous piece of erotica purporting to be by the authoress of a well-known French grammar book. In 1928 he founded the review *Distances*. Nougé served briefly in the Second World War but continued to write art criticism; he published the important study *René Magritte ou les images défendues* in 1943. With Magritte he developed a theory called *Surréalisme en plein soleil*, which was published as a manifesto in 1945 and caused a rift with Breton. From 1950 he contributed to the review *Les Lèvres nues* and occasionally to Breton's review *La Brèche*. Nougé's theoretical writings were published as *Histoire de ne pas rire* in 1956.

Further reading

Apollinaire, Guillaume, *Apollinaire: Selected Poems*, translated and introduced by Oliver Bernard, London 1988

Aragon, Louis, *Paris Peasant*, translated by Simon Watson Taylor, London 1971 (first published as *Le Paysan de Paris*, Paris 1926)

Balakian, Anna, *Surrealism: The Road to the Absolute*, London 1972

Brandon, Ruth, *Surreal Lives: The Surrealists 1917–1945*, London 1999

Breton, André, Paul Eluard and Philippe Soupault, *The Automatic Message*, London 1997

Breton, André, *Mad Love*, translated by Mary Ann Caws, Nebraska 1987

Breton, André, *Manifestoes of Surrealism*, translated by Richard Seaver and Helen R. Lane, Ann Arbor 1972

Breton, André, *Nadja*, translated by Richard Howard, New York 1960 (first published Paris 1928)

Cardinal, Roger and Robert Stuart Short, *Surrealism: Permanent Revelation*, London 1970

Caws, Mary Ann, ed., *Surrealist Painters and Poets: An Anthology*, Cambridge, Mass. and London 2001

Caws, Mary Ann, ed., *Surrealist Love Poems*, Tate, London 2001

Chadwick, Whitney, *Women Artists and the Surrealist Movement*, London 1991

Eluard, Paul, *Selected Poems*, selected and translated by Gilbert Bowen, London 1988

Fer, Briony, David Batchelor and Paul Wood, eds., *Realism, Rationalism, Surrealism: Art Between the Wars*, London and New Haven 1993

Freeman, Judi, *The Dada and Surrealist Word-Image*, Cambridge, Mass. and London 1989

Gale, Matthew, *Dada and Surrealism*, London 1997

Gascoyne, David, *A Short Survey of Surrealism*, London 2000 (first published London 1935)

Krauss, Rosalind E., *The Originality of the Avant-Garde and Other Modernist Myths*, Cambridge, Mass. and London 1986

Krauss, Rosalind E. and Jane Livingston, eds., *L'Amour Fou: Photography and Surrealism*, exh. cat., Corcoran Gallery of Art, Washington 1985

Levy, Julien, *Surrealism*, New York 1936 (reprinted New York 1995)

Mundy, Jennifer, ed., *Surrealism: Desire Unbound*, exh. cat., Tate, London 2001

Nadeau, Maurice, *The History of Surrealism*, translated by Richard Howard, London 1968 (first published Paris 1964)

Polizzotti, Mark, *Revolution of the Mind: The Life of André Breton*, London 1995

Credits

Text copyright

Paul Eluard
Facile © Editions Gallimard

'The Sheep' ('Les Moutons'), *Répétitions*, Au Sans Pareil, Paris 1922 © Editions Gallimard. Translation: David Gascoyne, *Selected Verse Translations*, Enitharmon Press, London 1996. Used by permission of Enitharmon Press

'The Word' ('La Parole'), *Répétitions*, Au Sans Pareil, Paris 1922 © Editions Gallimard. Translated by the author

'Max Ernst', *Capitale de la douleur*, Editions Gallimard, Paris 1926 © Editions Gallimard. Translation: Roland Penrose, *Surrealist Paintings by Max Ernst*, The Mayor Gallery, London 1937. Used courtesy of the Roland Penrose Collection, Chiddingly, East Sussex

André Breton
Soluble Fish (*Poisson soluble*), Editions Gallimard, Paris 1924 © Editions Gallimard. Translation: André Breton, *Manifestoes of Surrealism*, translated by Richard Seaver and Helen R. Lane, Ann Arbor, University of Michigan Press, 1969. Used by permission of University of Michigan Press

'The Vertebral Sphinx' ('Le Sphinx Vertebral'), *Le Révolver à cheveux blancs*, Cahiers Libres, Paris 1932 © Editions Gallimard. Translation: *Poems of André Breton*, translated by Mary Ann Caws and Jean-Pierre Cauvin, University of Texas Press, Austin 1982 © Editions Gallimard

Michel Leiris
'The Country of My Dreams' ('Le Pays de mes rêves'), *La Révolution Surréaliste*, no.2, 15 January 1925. Translation: *The Autobiography of Surrealism*, edited by Marcel Jean, Viking Press, New York 1980. Copyright © 1980 Marcel Jean. Used by permission of Viking Penguin, a division of Penguin Putnam Inc.

'Joan Miró', translated by Malcolm Cowley, *The Little Review*, Spring–Summer, New York 1926

Louis Aragon
'A Feeling for Nature at the Buttes-Chaumont' ('Le Sentiment de la nature aux Buttes-Chaumont') and 'The Passage de l'Opera', *Le Paysan de Paris*, Editions Gallimard, Paris 1926

© Editions Gallimard. Translation: Louis Aragon, *Paris Peasant*, translated by Simon Watson Taylor, Exact Change, Boston 1994. Used by permission of Exact Change, Boston

Paul Nougé
'René Magritte or Images Defended' (René Magritte ou les images defendues'), *Histoire*, translated in *René Magritte: catalogue raisonné*, edited by David Sylvester, Philip Wilson, London 1992

'The Overturned Mirror' and 'The Problematic Spectacle', Paul Nougé, *Works Selected by Marcel Mariën*, translated by Iain White, Atlas Press, London 1995. Used by permission of Atlas Press

Salvador Dalí
'The Great Masturbator', Salvador Dalí, *La Femme Visible*, Editions Surréalistes, Paris 1930. Translation: *The Autobiography of Surrealism*, edited by Marcel Jean, Viking Press, New York 1980. Copyright © 1980 Marcel Jean. Used by permission of Viking Penguin, a division of Penguin Putnam Inc.

'The Metamorphosis of Narcissus', Salvador Dalí, *The Metamorphosis of Narcissus*, translated by Francis Scarpe, Julien Levy Gallery, New York 1937. Quoted with permission kindly granted by the Gala-Salvador Dalí Foundation www.salvador-dali.org

Image copyright

Works illustrated are copyright as follows:

Arp, de Chirico, Hugo, Oppenheim, Tzara © DACS 2002
Breton, Ernst, Giacometti, Magritte, Masson, Miró © ADAGP, Paris and DACS, London 2002
Buñuel © Contemporary Films Limited
Dalí © Salvador Dalí, Gala-Salvador Dalí Foundation/DACS, London 2002
Duchamp © Succession Marcel Duchamp/ADAGP, Paris and DACS, London 2002
Man Ray © Man Ray Trust/ADAGP, Paris and DACS, London 2002
Tanguy © ARS, New York and DACS, London 2002

Other works © the estate of the artist

Credits

Index

Index